DURHAM CITY
IN COLOUR
1960–1970

Michael *&* Michelle Richardson

AMBERLEY

Michael and Michelle Richardson.

First published 2011

Amberley Publishing
The Hill, Stroud
Gloucestershire, GL5 4EP

www.amberley-books.com

Copyright © Michael Richardson, 2011

The right of Michael Richardson to be identified
as the Author of this work has been asserted in
accordance with the Copyrights, Designs and
Patents Act 1988.

ISBN 978 1 4456 0465 7

British Library Cataloguing in Publication Data.
A catalogue record for this book is available from
the British Library.

Typesetting by Amberley Publishing.
Printed in Great Britain.

INTRODUCTION

Durham City in Colour consists of 180 images, from 1960 to 1970. This is the first time that such a book has been published, showing the colourful city of the 1960s. The photographs show street scenes, events, transport (including the old bus station on North Road) as well as local people at work and play. Many (marked with the initials JS) were taken by the late Jack Stanton, who ran a fish and chip shop business in the city. We often think of this time as a 'black and white' era, mainly because, when we look back at family photographs, almost all are like this. Those selected have been carefully chosen to cover the period.

Some illustrations focus on new buildings, such as Kingsgate Bridge and Dunelm House in New Elvet, Millburngate House and Durham County Hall. Others show the first phase of roadworks from Gilesgate to Millburngate. Also covered is the preparation for the second phase of the road programme linking Millburngate to North Road and then on to Crossgate Peth.

Many will remember familiar shops, now long gone. For example, Greenwell's grocer's in Silver Street, Stanton's fish and chip shop in Millburngate (later at Neville Street), Earl's confectioner's (famous for their meat pies), Saddler Street and Dimambro's ice-cream parlour in Claypath. All of these premises had their own distinctive aroma. Many industries that once flourished in the city are shown, such as Blagdon's leather works in Millburngate, Hauxwell's iron foundry at Atherton Street and Mackay's carpet factory in Freeman's Place.

It is surprising how many public houses we had in the city, when compared with the numbers of today. Some of these were lost in the 1960s: the Volunteer Arms Hotel and the Durham Ox, Gilesgate; The Maltman Inn, Wearmouth Bridge, the Wheatsheaf and the Kings Arms, Claypath; The Royal Hotel and Railway Hotel, Castle Chare; the Station Hotel and King William IV, North Road; The Criterion, 1 & 2 South Street; The Five Ways Inn, Millburngate, and the Blue Bell Inn and Tanners' Arms in Framwellgate.

As you peruse these pages, they will no doubt stir your memories and arouse your interest in what was once there and has now gone. I trust that this collection will bring as much pleasure to you, the reader, as it has to us in putting it together.

Michael and Michelle Richardson
2011

ACKNOWLEDGEMENTS

So many people have donated and loaned photographs to the Gilesgate Archive that it is impossible to thank them all. Special thanks go to Mr John Austin, Mr Frank Bilton, Mr John Bygate, Mr Sidney and Mrs Vera Davidson, Mr Ian Forsyth, Mr Peter R. W. Grundy; M. Whitfield Ltd, Mr Peter Jefferies, Mr George Hetherington, Mr Richard Hopps, Dr Bob Kell, Mr Chris Lloyd, Miss Dorothy M. Meade, Mrs Dorothy Rand, Mr Stan Rand, Mr George Robert Savage Nelson, Miss Emma Richardson, Miss Michelle Richardson, Mrs Norma Richardson, Mr Liam Sheriff, the late Mr Jack Stanton, Mr Mark Tallentire, Mrs Janet Thackray and Miss Hilary Webster. Also, thanks to Clayport Library (reference section), the Dean and Chapter Library and The History of Durham Project.

If any readers have new material, photographs, postcards, slides, negatives or information, they should contact:

Gilesgate Archive,
c/o Michael Richardson,
128 Gilesgate,
Durham,
DH1 1QG

E-mail: gilesgatearchive@aol.com
Telephone: 0191 3841427

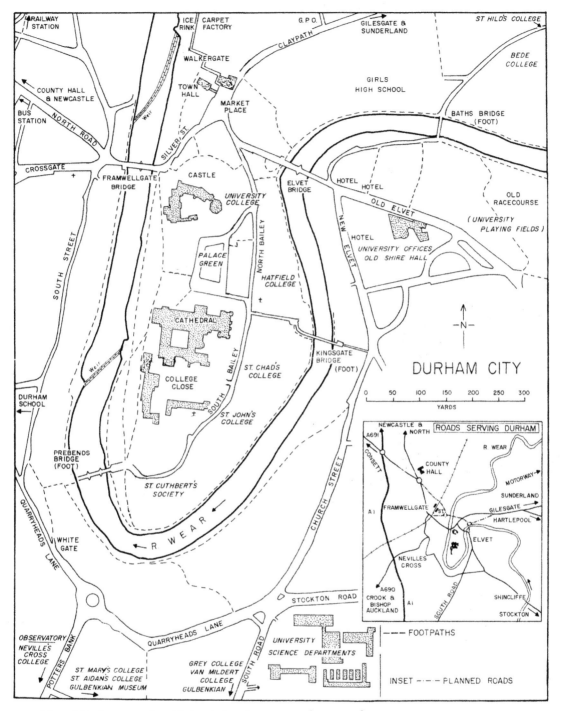

Map of Durham *c.* 1964 with inset showing proposed new roads.

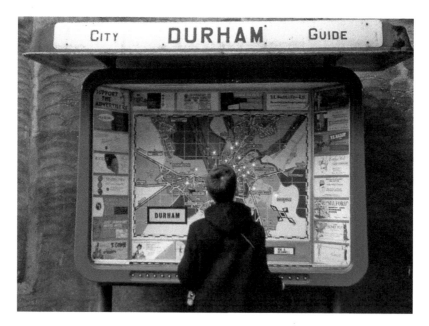

The useful Durham City location guide, *c.* 1966: several of these were situated around the city centre. Many youngsters took great pleasure in trying to press as many buttons as possible, to illuminate the location lights. Perhaps this image might spur a suggestion for the installation of some solar-powered models.

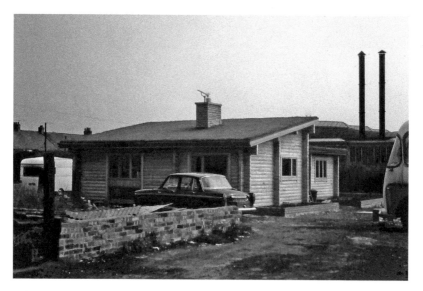

Gilesgate Moor, 1968: a Norwegian-style log cabin, complete with turf roof. It was the home of Harold and Margaret Cooper, who had it built after seeing one like it at the Ideal Home Exhibition in London. It was constructed using 2 tons of pine from Norway, and cost £8,000. The Coopers ran a coach business on the site of what was originally Strawberry Farm. Immediately behind the cabin, to the right, is Mackay's new carpet factory, officially opened in May 1970. The whole area is now occupied by Tesco's car park. The car is a Hillman Minx and to the right is a Commer Coach. (JS)

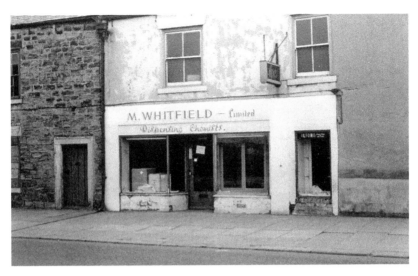

The shop front of M. Whitfield Ltd, *c.* 1968, the dispensing chemist at 18 Sunderland Road, shortly before it was demolished. In 1954, the pharmacy transferred here from Sherburn Road. In 1965, they were notified that this property was to be compulsorily purchased as part of a redevelopment plan by Durham County Council. M. Whitfield Ltd therefore purchased four small cottages – 34, 35, 36 and 37 Sunderland Road – from the Church Commissioners, and applied for planning permission to convert these into shop premises. Durham County Council turned down the application, and it was only after a public inquiry, supported by Durham City Council, that permission was granted.

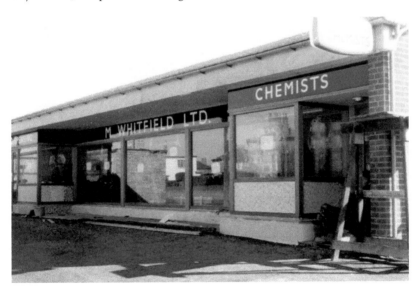

34 Sunderland Road, Gilesgate: the newly constructed premises belonging to M. Whitfield Ltd. The main building contractor was J. F. Harrison, Shotton Colliery. The photograph shows the final touches being added in early 1967. Their first pharmacy in Durham City opened in 1941, at the Empire Buildings, Sherburn Road, and was originally managed by Miss Mary Whitfield, the daughter of the company's founder.

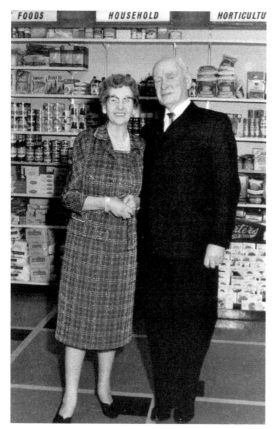

Left: Company founder Mr Joseph Strachan Whitfield and his wife Margaret (the 'M' in M. Whitfield Ltd) at the official opening of the new pharmacy in Gilesgate, April 1967. Their first shop was established at Horden, in 1935, and by 1967 they had nine shops between Durham and Middlesbrough.

Below: Mrs Margaret Whitfield, with guests including staff and members of the local doctors' surgery, at the official opening of M. Whitfield Ltd's pharmacy, Gilesgate, April 1967. The two blondes are sisters, Rita McIntosh and Eileen Hall (née Shiell), and the girl on the right in the blue two-piece is Marie Anderson. The shop had a number of departments, specialising in jewellery, cosmetics, toiletries, baby goods, horticulture and an extensive range of photographic equipment.

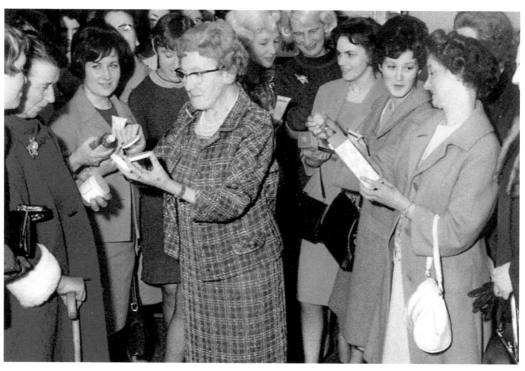

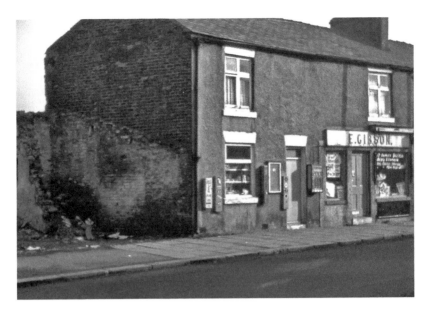

The business premises belonging to Evelyn Gibson, grocer, 21 Sherburn Road, 1967, demolished late in the 1960s to make way for the site of a new supermarket, now Sainsbury's. The shop front was approximately where the bus stand is now located near the 'road ends'. Many will remember the sweet dispensers and cigarette machine attached to the front wall. (JS)

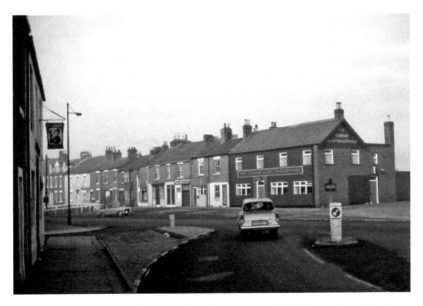

Looking towards the Durham Light Infantryman public house from Sherburn Road Ends in 1968. This was previously called The Bay Horse, and was renamed in January 1968. On the extreme left is the frontage of the Queen's Head public house. In the distance, to the left, is Alan's, the gents' hairdresser. Further to the right of it was Alan Wilson's DIY shop and next to that, on its right, the business premises of John Blenkinsop, undertaker. The two cars are a 1968 Ford Anglia and, over the road to the left, an Austin A40. (JS)

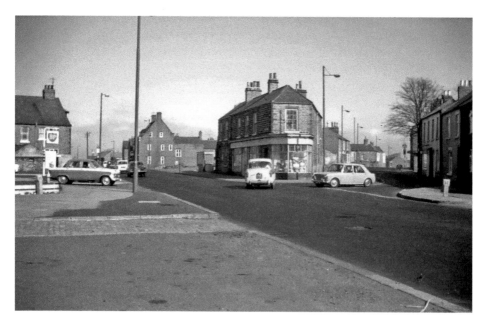

Sherburn Road Ends, seen from the Durham Light Infantryman public house, 1968. The large building in the distance is the gable end of the Three Horseshoes public house now called The Shoes. The central stone building is the old Co-operative Store. This area was known as the 'store corner'. The open space behind the bus shelter, in the centre of the photograph, is where the present-day supermarket and shops stand. The cars in the foreground are, left to right, an Austin A50, Standard Vanguard and a Morris 1100. (JS)

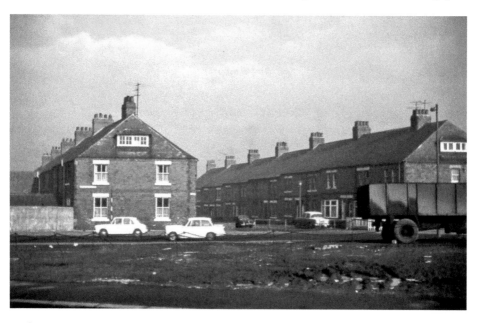

Looking across to Wynyard Grove from Sherburn Road, c. 1969. The area between the two roads had been cleared and was being prepared for the building of a new Frank Dee Supermarket and small retail shops. The two cars on the left are an Austin or Morris 1100 and a Triumph Herald. (JS)

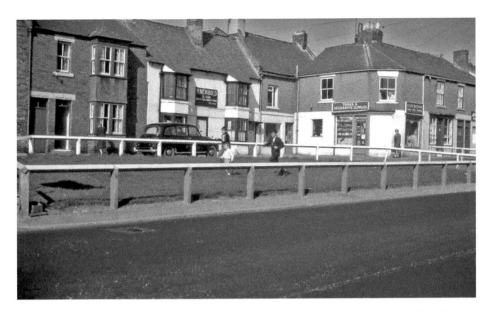

The fenced green area is on the opposite side of the road to the 'duck pond' (Gilesgate Green), 1968. Across the road, we have the business premises of Newbold & Son, wholesale confectioner, Alan Wilson, timber and decorative supplier, and John Blenkinsop, undertaker. The property occupied by Newbold's was once the Smiths' Arms public house. The car is an Austin London-type taxi. (JS)

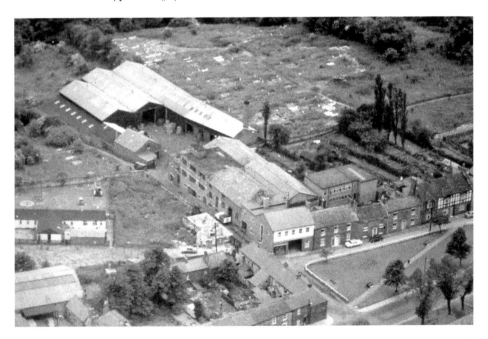

An aerial view, towards the south, of the top of Gilesgate in the early 1960s. On the left is the old Gilesgate Nursery School. The buildings in the central part of the photograph were Wood & Watson Ltd, mineral water manufacturers and bottlers, 132 Gilesgate. On the right is the area known locally as the 'duck pond'. At the top of the photograph is the 1927 cemetery belonging to St Giles' church.

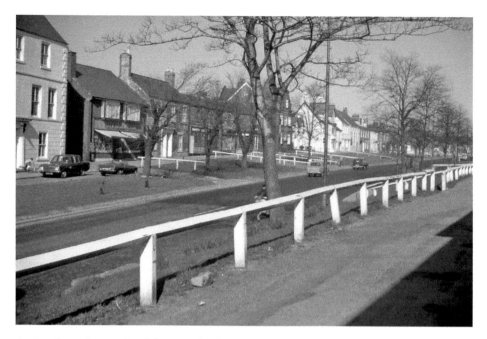

A view from the south, of the top of Gilesgate Bank, shows the distinctive white railings, 1968. The shop over the road on the left hand side was Heslop's fruit and grocery, 91 Gilesgate. The vehicles on the left are a Ford Cortina MkII and an MGB sports car. (JS)

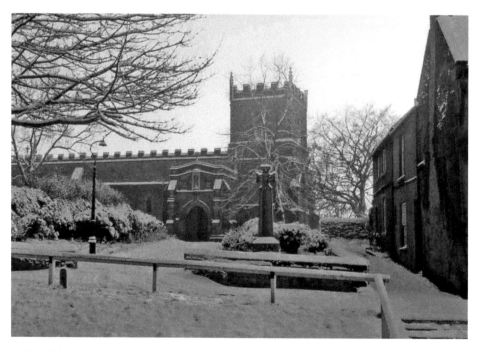

St Giles' church, 1963, showing the church drive lined with shrubs, taken by Hilary Webster. On the right is Church Lane, the original entrance from the road. The war memorial commemorates ninety-seven men from the parish, and was unveiled 6 May 1925. The church, founded 1112, celebrates its 900th birthday in June 2012.

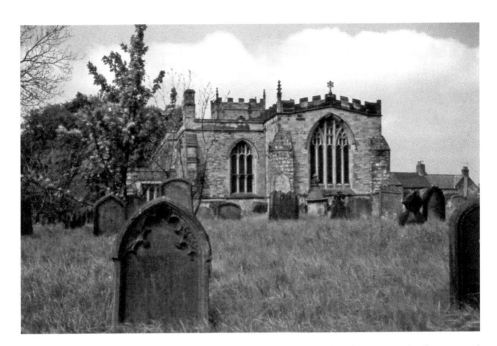

St Giles' church, *c*. 1962, showing the east window. All of the headstones in the foreground were unfortunately removed in 1965, at the request of the parochial church council and the Vicar Revd E. G. Casey, at a cost of about £300. Only a small selection were saved. These now stand against a wall to the south of the church.

Looking down Gilesgate Bank, early 1960s. On the opposite side of the road is a group of properties which were once owned by the Gilligate Trust. The site was later cleared, and in the 1980s new town houses were built on this location. One of the properties on the front, 171 Gilesgate, was once the Royal Oak Inn. The car on the left looks like an old Austin.

A view from the bottom of Gilesgate Bank, *c.* 1965. All the property on the right was demolished to make way for the new through-road in the late 1960s. The lower building on the left was at this time a motorcycle showroom belonging to Cowies. The large building in the centre was the Volunteer Arms Hotel. A little further to its left was the stone-built Drill Hall belonging to the 8th Battalion Durham Light Infantry (*see p. 16*). The cars are both Minis. (JS)

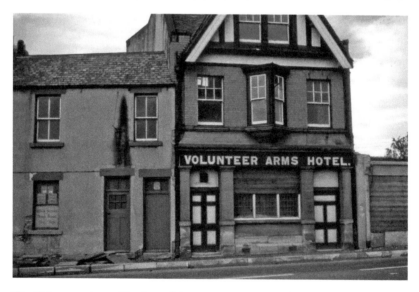

The Volunteer Arms Hotel, 47 Gilesgate, just prior to demolition, *c.* 1966. The property on the left had been used as a storage building for Brooke Bond Tea (note the posters in the window). The partly demolished building on the right was last used by Cowies' Motorcycles, who also had two other properties nearby. The public house was named after the volunteers who met in the nearby Drill Hall. (JS)

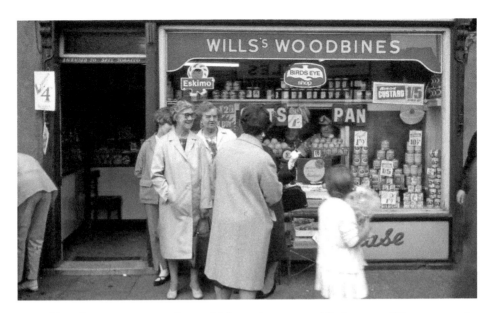

A neighbourly conversation in front of Johnson's grocer and fruiterer, 45 Gilesgate, *c.* 1965. This was situated between the Volunteer Arms Hotel and Station Lane at the bottom of Gilesgate Bank. The business had originally been Johnson and Cosgrove. *Note*: the label for Birds Custard in the top right corner of the window shows the old price of 1*s* and 5*d* (just over 7p). The hand-written notice on the doorway reads: 'Lemonade 4*d* the glass'.

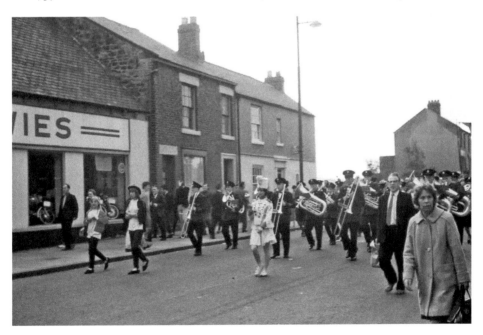

Looking towards Cowies' motorcycle showroom, at the bottom of Gilesgate Bank, *c.* 1965. This was originally St Giles' Parish Room, and later a showroom for Archibald's builders' merchants. The open area to the right of the house, in the centre, was partly occupied by Lowes' marble works. The photograph was taken on a Miners' Gala Day and shows a brass band and its followers heading home.

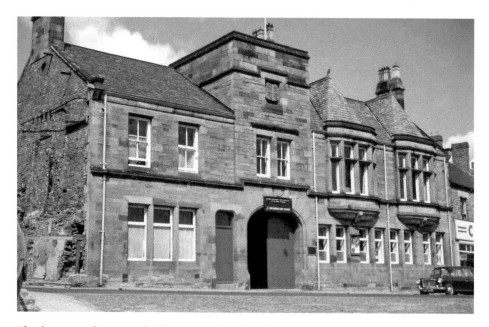

The fine stone frontage of Gilesgate Drill Hall, the home of the 8th Battalion Durham Light Infantry, *c.* 1965. The building, opened 7 February 1902, stood on the north side of the road, at the bottom of Gilesgate Bank, and was demolished for the new through-road in the 1960s. The Durham Ox public house previously stood next door on the left. The car is an MG 1300 Saloon.

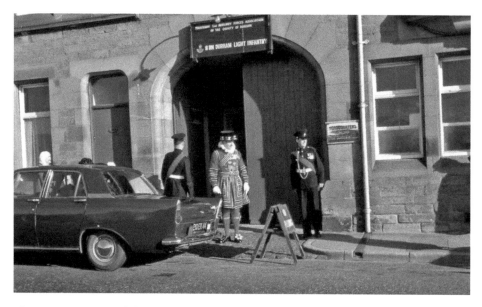

The main entrance of the Drill Hall, Gilesgate, Maundy Thursday, 23 March 1967. The central figure is wearing the uniform of the Royal Bodyguard of the Yeomen of the Guard. The Queen travelled to Durham by train, and drove through the city to the castle, before walking over Palace Green to the cathedral. This was the only time that the Maundy service had been held in Durham. The car, a 1960s Ford Zephyr 4, painted khaki, has army registration plates. (JS)

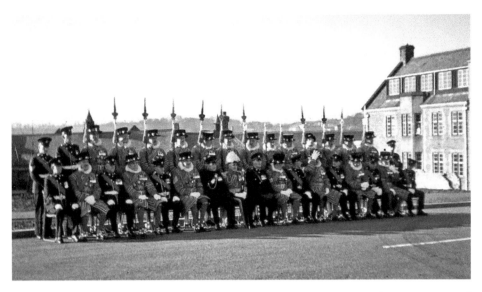

Members of the Royal Bodyguard of the Yeomen of the Guard with their captain, Lord Bowles, and officers of the 8th Battalion Durham Light Infantry, Maundy Thursday, 23 March 1967. The Yeomen of the Guard are not to be confused with the Yeomen Warders of the Tower of London – popularly known as Beefeaters – a similar but distinct body. The photograph was taken on the opposite side of the road to the Drill Hall at the bottom of Gilesgate Bank. The large building on the right is student accommodation belonging to St Hild's College. (JS)

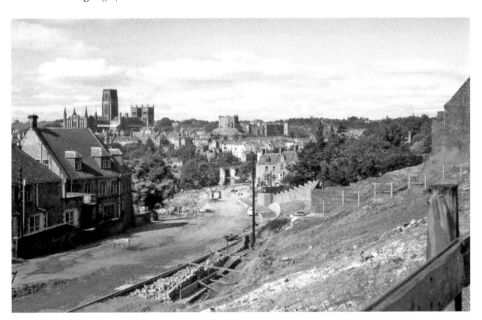

A view of the cathedral and castle from the bottom of Gilesgate Bank, 1966. The stone property on the left belongs to Bede College. At the time of the photograph, the new Leazes Road was being constructed. A concrete footbridge now crosses at this spot, erected in around 1971. In the late 1960s, the *Durham County Advertiser* described this view as being one of the finest in Europe. (JS)

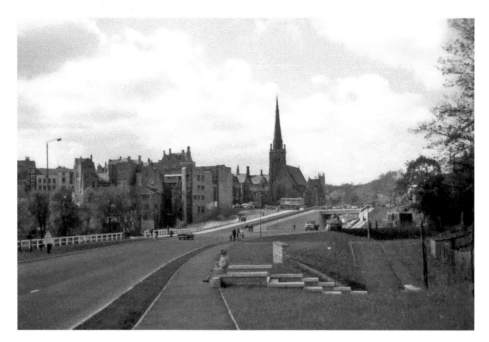

A view of St Nicholas' church from the newly constructed Leazes Road, 1967. In the foreground, a shopper rests near the steps, leading to an underpass taking you in the direction of the river. The open area in the central part of the photograph is now occupied by the Prince Bishops Shopping Centre.

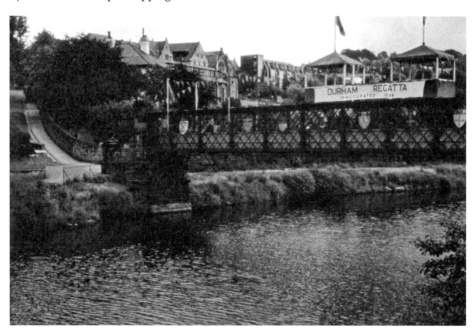

A view of the old Baths Bridge from the Elvet side, looking towards Bede College and the Chapel of St Bede, c. 1960. The bridge is decorated for the Durham Regatta with temporary boxes for the officials. This was the second bridge on this site and was opened about 1896. It was replaced by the present concrete one, officially opened 16 June 1962. (JS)

The grounds of St Hild's College, *c.* 1965, taken by Stan Rand. The building in the background on the right is the former college chapel. The young student in the group is Dorothy Rand (née Noble), author and local historian. The ladies are Ena Noble, left, and Mary J. Smith, right. The car is a 1965 Newcastle-registered Ford Cortina.

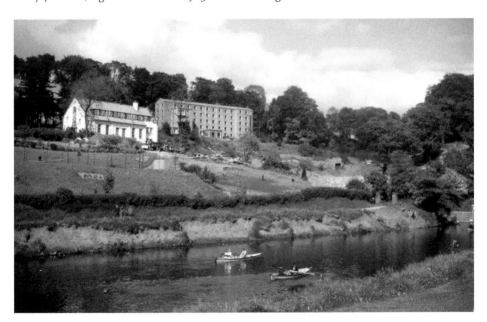

The building on the right is the new Christopher Wing (named after Eleanor C. Christopher, a former principal) belonging to St Hild's College, viewed from The Racecourse, 1968. The construction work in the college grounds was for a new concrete culvert and sewer pipe. The photograph was taken before the St Hild's boathouse and landing stage were built. Note the poor condition of the riverbank. On the far right of the picture is the towpath entrance into Pelaw Wood. (JS)

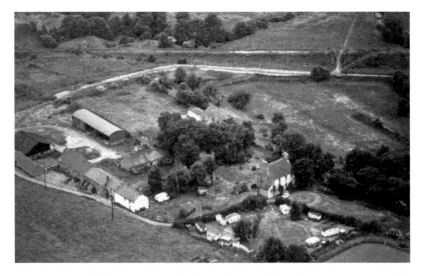

An aerial view looking south of Old Durham Gardens, late 1960s. Across the top of the photograph is the disused railway embankment leading to Elvet Station. The large whitewashed building to the right was the old Pineapple Inn. A little behind that is the gazebo and walled garden of the former manor house, which was situated behind the cottages and barn to the left. At the bottom of the picture is a small caravan park that was mainly used by people from the Sunderland area.

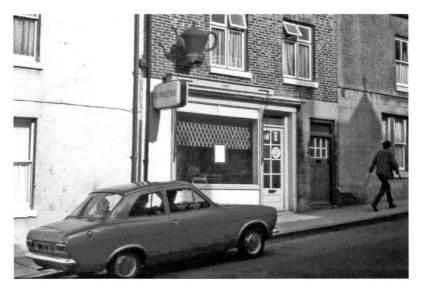

One of two shops belonging to Fowler, the grocer, 57 Claypath, 1970 (the other was on the corner of Flass Street). Above the shop can be seen the famous Durham 'Tea Pot', which had many homes in the city. Since 1970, it has hung above a shop in Saddler Street. Fowler's shop had previously been further down, at the bottom end at 99 Claypath. It was demolished for the new through-road in 1966. The shop pictured will be remembered by many as the chemist opposite the former doctors' surgery in Claypath. Around the early 1970s, Ray Middleton had it as a grocer's. The car is a Ford Escort, G-reg (1969). (JS)

Right: The girls' entrance, Bluecoat School, Claypath, late 1960s, taken by Janet Thackray. The land is now occupied by town houses called Bluecoat Court, reached through an archway left of the Big Jug public house. The pupils moved to a new school at Newton Hall in 1965, officially opened by Lord Barnard, 18 March 1966.

Below: An interior view of the main hall of the closed Bluecoat School, Claypath, late 1960s, taken by George Hetherington. A heating stove once stood in the brick alcove, but the large antique wall clock, now quite valuable, was left behind. Photographs exist showing this clock in the 1900s. The hall could be partitioned off to form class rooms.

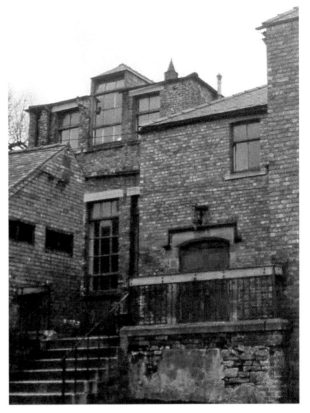

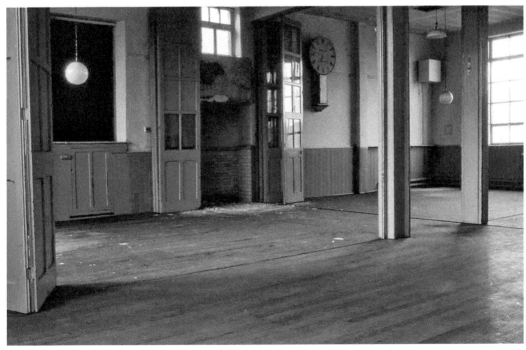

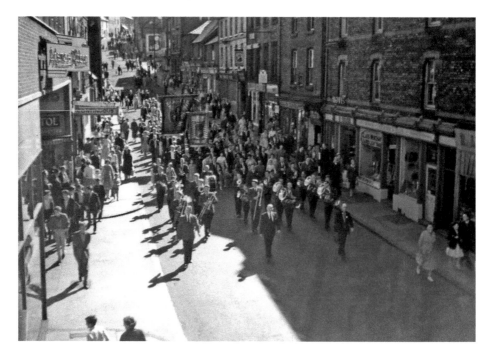

The band and lodge banner belonging to New Herrington Colliery, travelling down Claypath on Miners' Gala Day, early 1960s. The small one leading is the production banner, which was awarded to the colliery with the highest output that year in the Durham coalfield. On the left is Adams & Gibbons car showroom (now Kwik-Fit).

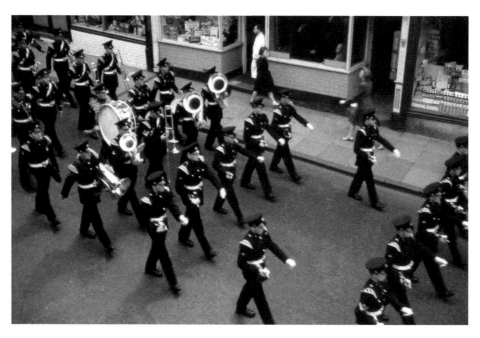

A band, belonging to the 8th Battalion of the Durham Light Infantry, marching through Claypath, 1961. The chap at the doorway in the white coat is a member of the Dimambro family, who were famous for their ices and confectionery business at number 90.

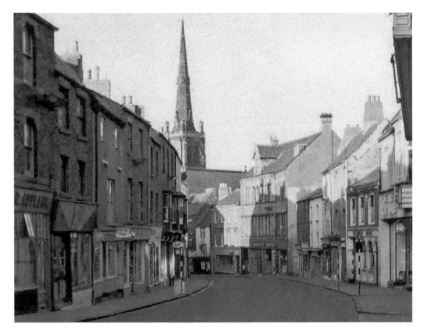

The lower part of Claypath, *c.* 1964, taken by Janet Thackray. Most of the buildings to the right of the road were later demolished to make way for the new through-road. On the extreme left is 88a, the shop of Raymond Appleby, butcher. The large property in the central part of the photograph is the old Claypath Co-operative Store.

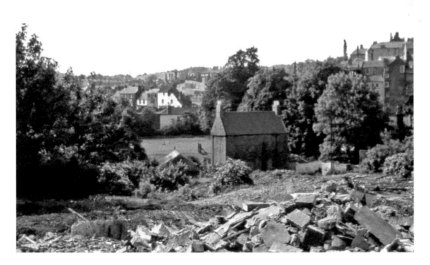

Looking towards Brown's Boathouse from the bottom end of Claypath, 1965, taken by Janet Thackray. In the centre of the photograph is Ivy Cottage, which then overlooked the playing field belonging to the girls' high school (Leazes House). Note it has no windows at the rear. The area to the right of the photograph was partly occupied by Paradise Lane.

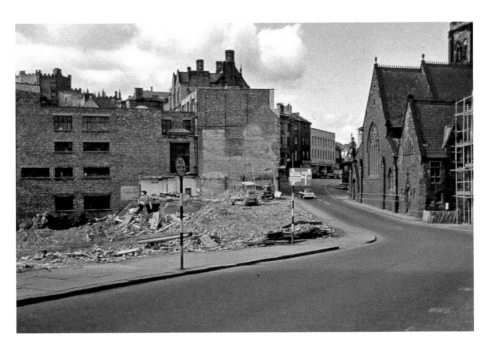

The lower end of Claypath, shortly after the buildings were demolished, *c.* 1965, taken by Janet Thackray. The large brick building was then Doggart's Department Store. It is now Boots, the chemist. A section of the waste ground is now occupied by the Prince Bishops Shopping Centre. The central area is now the site of the Claypath underpass.

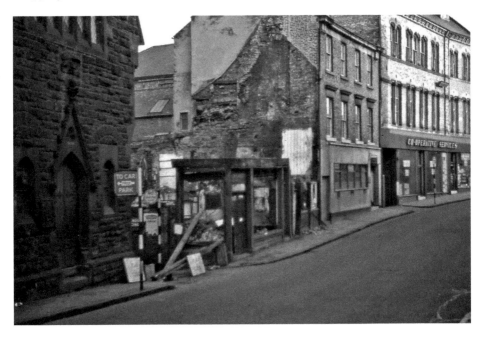

The north side of the bottom of Claypath, *c.* 1965, taken by Janet Thackray. Left to right: St Nicholas' church hall, the entrance to Palace Lane (Walkergate), Fleming and Neil, ironmongers, the outline of the demolished Wheat Sheaf public house, the Co-operative Bank and the Co-operative Store. This whole area is now occupied by the Claypath underpass.

Right: Looking towards the back of St Nicholas' church, *c.* 1963, taken by Janet Thackray. On the right, the north wall of the indoor market. The derelict area in the foreground had previously been occupied by the Palace Cinema. The Millburngate Bridge now crosses over this site.

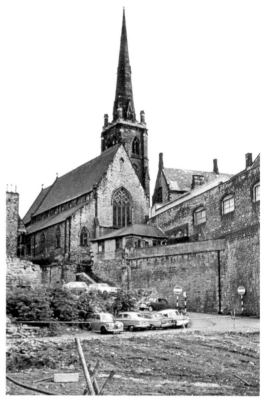

Below: The cobbled courtyard of Fowlers Yard, situated on the west side behind Silver Street, 1970. The blue car is a Hillman Hunter Estate, Durham registered, H-reg (1970), and behind is a Rover P5. The storage buildings are now occupied by several independent business units. (JS)

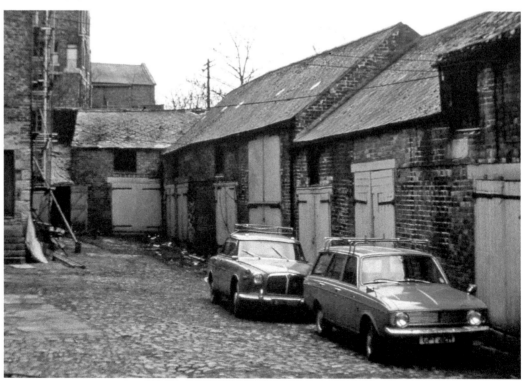

Fowlers Yard, looking towards the back of the indoor market, 1965. The building and garages across the central part of the photograph were later demolished. The two garages on the right are now occupied by a coffee shop. The car on the right is an 'Aunty' Rover, and the one partly seen on the left is a Morris Oxford. (JS)

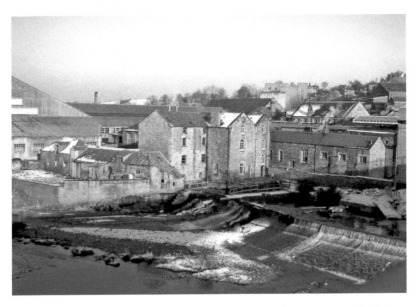

A snowy view from the newly built Millburngate Bridge, c. 1968. To the left, it shows the ice rink, and then the small pan-tiled roof of the medieval Bishop's Mill, where 'Icy Smith' generated hydroelectricity. The larger building, attached later to the original mill, was used as an air-raid shelter during the Second World War, and also as a canteen by Canadian airmen, who introduced ice hockey to Durham. It was also known as Martin's Mill and Market Place Mill. The buildings behind and to the right belonged to Mackay's carpet factory. (JS)

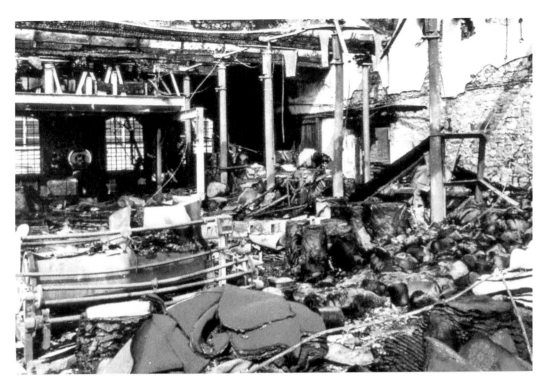

Above: Mackay's carpet factory, Freeman's Place, showing the aftermath of the fire that started in the card shed on 5 May 1969. Almost the entire Wilton department was wiped out with the loss of No. 2 and partial loss of No. 1 sheds (only twenty looms survived out of about forty). The fire had been started by an unsettled employee who was later caught and sent to prison.

Right: Mackay's wool store, photographed after the fire of May 1969. The fire was brought under control by the attendance of nineteen fire engines. The area is now part of the Millennium Place development.

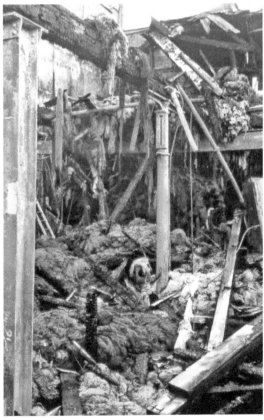

A football match at Ferens Park, which was situated near The Sands, 1961. The teams were Durham City and Bishop Auckland, final score 1–0. The football ground was sold around 1994, and a replacement built at Belmont Industrial Estate. The old ground is now occupied by a private housing development.

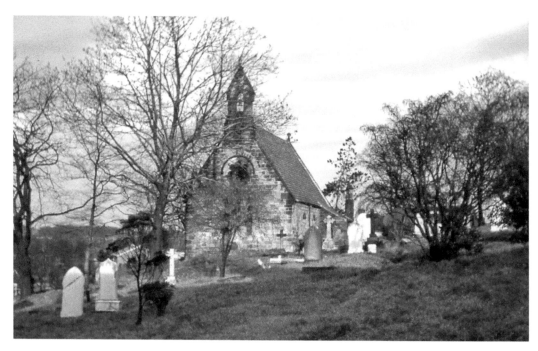

St Nicholas' cemetery, situated at the bottom of Providence Row, overlooking The Sands, c. 1960, taken by Janet Thackray. The mortuary chapel was consecrated in 1861. The 2 ½ acre site, complete with two cottages, had previously belonged to the Trustees and Executors of the late Thomas Ebdon. After many years of standing derelict, it was taken over as a storage building for architectural salvage by the local authority.

Right: The Londonderry statue in the Market Place, early 1960s. The gentleman on the right is pointing towards the horse, as someone has mischievously placed a nosebag over its mouth. Note the bus stands on the left, removed in July 1968. Unfortunately, the Londonderry statue was moved recently, a short distance to the south at great expense and despite a public outcry with over 6,000 people signing a petition.

Below: A busy market day in 1960s Durham City. Note, on the left, the advertisement for Capstan cigarettes attached to the wall of Donkin's wholesale & retail tobacconist and confectioner, 22 Market Place. (JS)

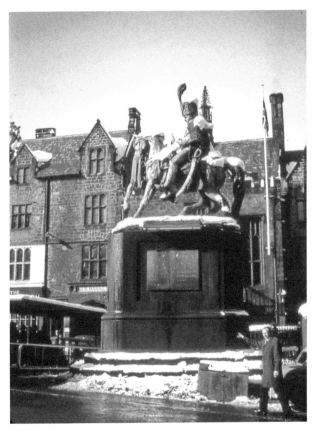

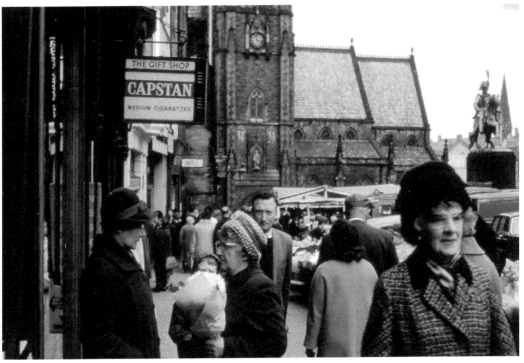

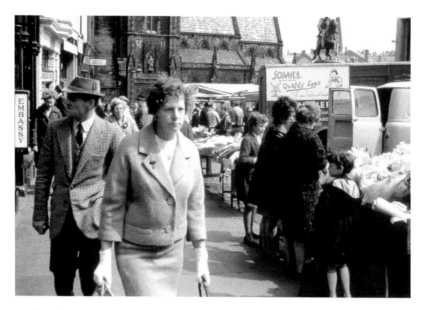

Market day shoppers, Durham City, 1968. On the right is the flower stand, which had been run by the same family for over sixty years. In May 1968, the City Council tried to close the outdoor market for good, on the grounds that the clean-up each Saturday was more costly than the rents received. A petition to keep the market was organised by the traders and the result was positive. (JS)

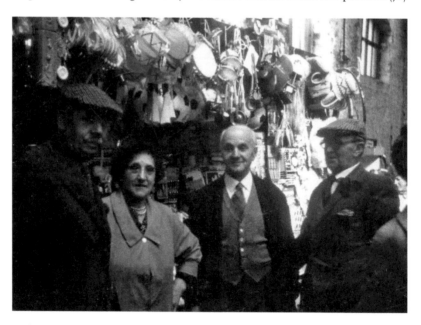

Bennie and Minnie Clark (the author's great-uncle and great-aunt), Durham Indoor Market, October 1969. The covered market was then only open on Saturdays. Bennie (seen without cap) had started work on his father's toy stall in 1918, after serving with the Northumberland Fusiliers in the 1914–18 war. They had both run the stall for fifty-four years, until their retirement in 1972. They also had a cycle and toy shop in Claypath, which was opened about 1920.

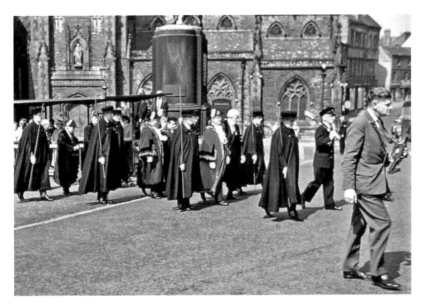

Mayor's Sunday, May 1964, taken by Janet Thackray. The position was held that year by Durham-born Cllr Norman Woods Sarsfield, who is seen with the new-look bodyguard. Councillor Sarsfield was awarded the Military Cross in the Second World War while serving in the Reconnaissance Corps. He rose through the ranks to become major, and from 1937 to 1953, he was the City of Durham swimming champion. The bodyguard dates back to the thirteenth century, when their duty was to protect the warden, appointed by the trade guilds to govern and oversee work carried out in the city.

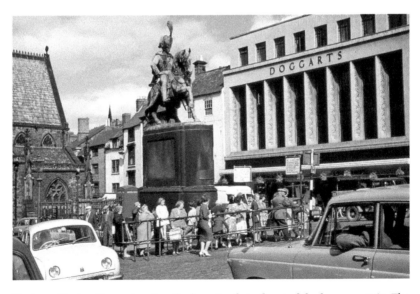

Durham Market Place, showing the bus stands in front of the horse, c. 1962. The buildings behind, part of lower Claypath, were later demolished. The green iron railings to the left of the photograph surrounded the gents' underground toilets, and the large building on the right was Doggarts Department Store. The two cars in the foreground are a Renault Dauphine, left, and a Morris Oxford, right.

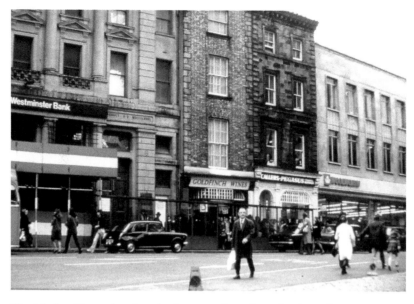

The Market Place, showing the bus stands and on the far right Woolworths (now Tesco) with its distinctive façade of white Portland stone, 1967. The first Woolworths opened in the city around 1928. Work started on the new store in May 1959, and it was officially completed 22 June 1961. The two small shops are Goldfinch Wine Store Ltd, 14 Market Place, and Callers-Pegasus, travel service. The bus is a United Bristol and the car an Austin 1100, waiting for the lights to change to drive down Silver Street – now pedestrianised. (JS)

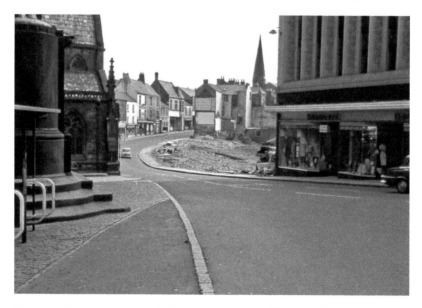

A view of the lower end of Claypath from the Market Place, 1965, taken by Janet Thackray. The derelict site to the left of Doggarts was later partly excavated to form the Claypath underpass. It had previously been occupied by a row of shops, two of which were Fowler the grocer's and Fred Robinson, pork butcher. The car in Claypath is a Mini.

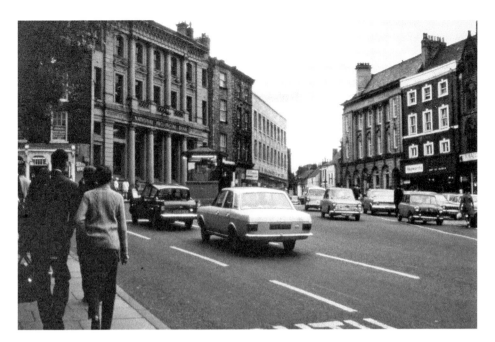

A busy Market Place, showing traffic waiting to turn at the police box towards Silver Street, 1960s. The two cars on the right are coming up from Silver Street. The left lane was for traffic heading south over Elvet Bridge. The six cars, left to right are a Ford Anglia, a Ford Cortina MkII, an Anglia, an Austin, a Ford Granada and a Mini (all 1960s). (JS)

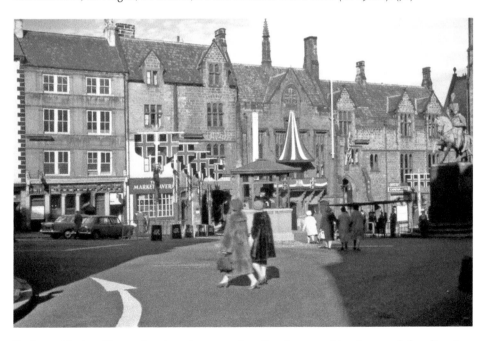

Durham Market Place, showing the second police box on this site, used for directing the traffic through the city centre, March 1967. Behind it is the town hall. The area had been decorated for a royal visit by Queen Elizabeth. Note the two ladies with the then fashionable fur coats. (JS)

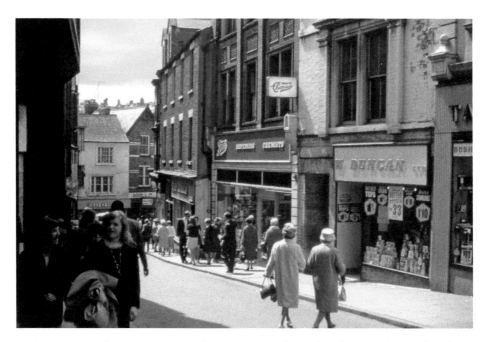

Looking down Silver Street, 1968. The opening to the right of Boots chemist led down to Back Silver Street. This vennel was relocated further up the street in the 1980s. The premises with the bright yellow signage, number 30, was a branch of Duncan Harrison Ltd., retail grocers. (JS)

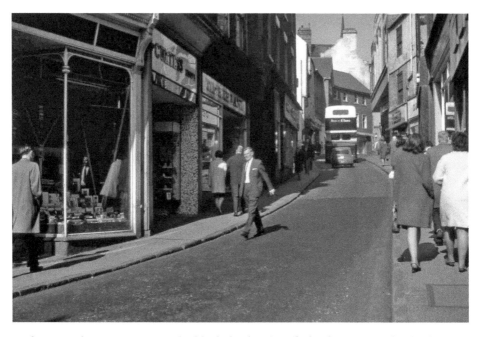

Looking up Silver Street, 1968. A double-decker bus (Sunderland District Leyland Atlantean) bound for Sunderland, followed by a Mini, approach the Market Place. The business, third up on the left, number 26, was Timberland, a national DIY chain, which later moved to bigger premises in North Road.

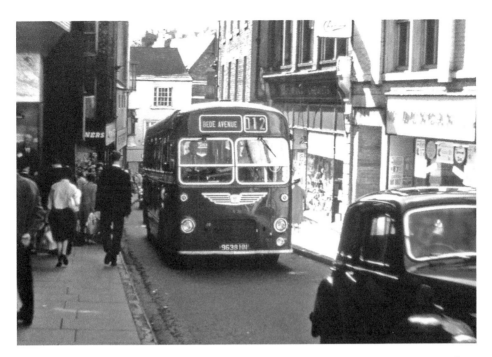

A Durham District Services bus (Bristol MW), the Bede Avenue 'D12 Service' travelling up Silver Street, 1968. The car looks like an old Austin. As you can imagine, it was fairly common for pedestrians to be clipped by wing mirrors whilst on the footpath. (JS)

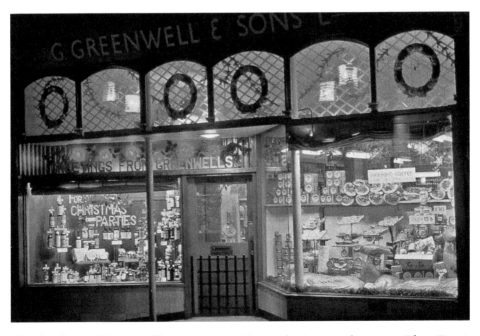

The shopfront of Greenwell's grocery, provision and wine merchants, 33 Silver Street, Christmas, c. 1962. The shop closed on this site in 1983. The business moved for a short time to North Road, before finally closing for good. Note the fine oak door, complete with wrought-iron decorative straps. It is now the general post office.

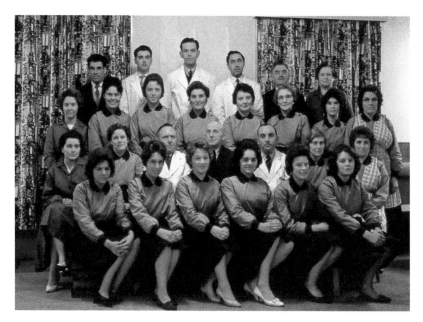

The staff of George Greenwell & Son's, 33 Silver Street, *c.* 1962. Back row, left to right: George Rowntree, Martin Murphy, Joe Stephenson, Sidney Davidson, Robert 'Rob' Robinson, and Hannah Robinson. Second row, left to right: Miss Ranson, -?-, Anne Layfield, Tina Abbott, Hilda Hall, Mrs Maidment, Thelma Curran, and Marjorie Lawson. Third row, left to right: Marion Staley, Annetta Thompson, Ralph Eland, George Greenwell, George Brighton, Isabel Wilson and Mrs Firman. Front row, left to right: Mary Blackey, Sandra Kirk, Shirley Fallon, Mildred Vine, Hilda Bargewell and Dorothy Watson.

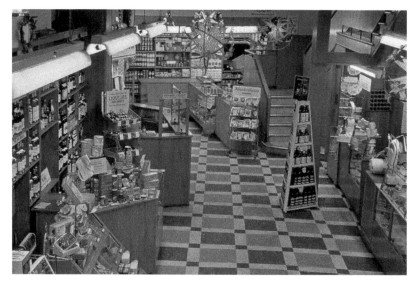

The interior of Greenwell's, looking towards the rear of the shop, *c.* 1962. The stairs on the right led up to the coffee lounge, a favourite meeting place for locals. Partly seen on the left is a selection of their fine wines and spirits, for which they were noted.

The coffee lounge (opened 1955), upstairs at Greenwell's, 33 Silver Street, *c.* 1962. They ground their own coffee and many will remember the aroma of it as you walked past the shop. The vending machine on the wall was for Players cigarettes.

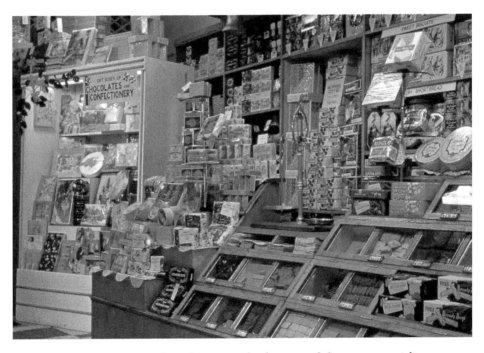

A close-up of the biscuit and confectionary display, one of the many specialist counters in Greenwell's shop, *c.* 1962. The glass-fronted self-service containers show a fine display of their biscuits; the ornate brass scales were for weighing them. The left display shows a selection of boxed chocolates.

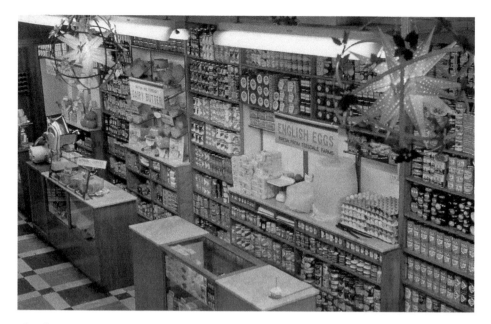

The dairy counter, Greenwell's, *c.* 1962. On the right is a very large block of butter, and above it a sign for fresh eggs from Teesdale Farms. The counters were made of marble so as to keep cool. Note the decorative arrangement of the goods on the shelves, and the ornate illuminated Christmas decorations.

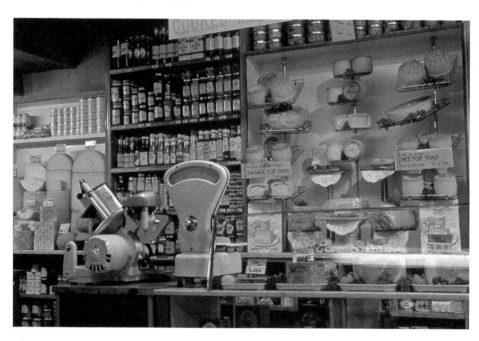

The meat counter, Greenwell's shop, *c.* 1962. They were noted for fine pork, veal and ham pies. To the left is part of the dairy counter display. Note the two signs for the famous high-class Saxby's pork pies. They had customers calling from a radius of 25 miles, travelling especially for their cheeses, coffee and delicatessen section. A sign above one of the joints offers cooked gammon at 2s 3d per quarter (11½p per 25 grams).

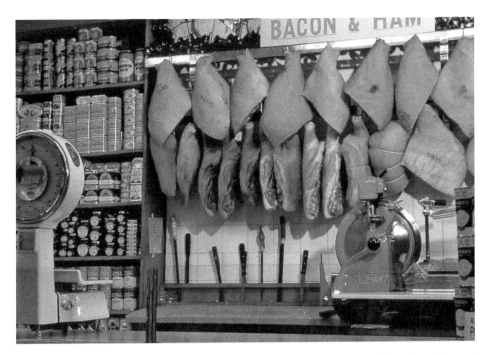

The colourful bacon and ham counter, Greenwell's, *c.* 1962. Some of the hams have 'Harris' stamped on the side (C. & T. Harris & Co., bacon curers, Calne, Wiltshire, were founded in 1770). The top three shelves on the left show an assortment of tinned meats. The name of Greenwell's stood for quality, and was well known throughout the county.

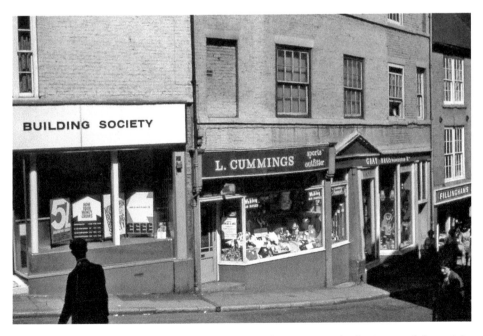

The road leading from Saddler Street to Elvet Bridge, *c.* 1960. The businesses left to right are the Northern Rock Building Society, L. Cummings' sports outfitter, 10 Elvet Bridge, Gray Brother's Newcastle Ltd electrical engineers and Fillingham the photographer. (JS)

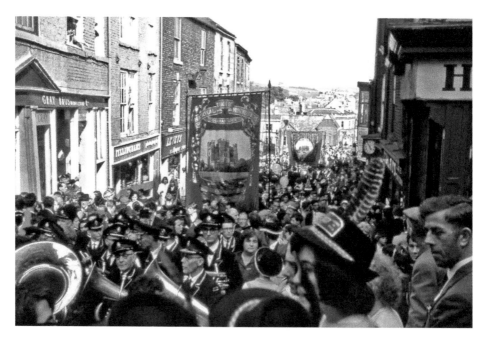

Durham Miners' Gala, Elvet Bridge, 1960s, taken by Janet Thackray. The band and banner belonged to Hylton Lodge and showed Hylton Castle. The one in the distance was Marsden Lodge. The three shops on the left are Gray Brothers' electrical engineers (*see p. 39*), Fillingham, photographer and Leveys, wallpaper shop.

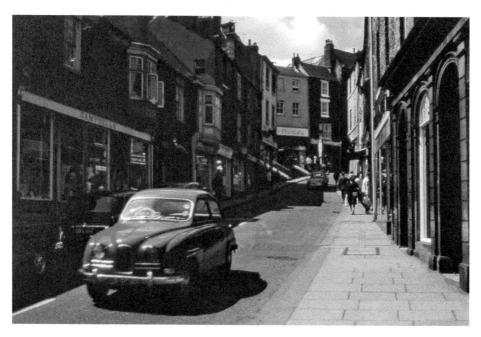

Looking up towards Saddler Street from Elvet Bridge, 1968. On the left was Campbell's children's outfitters. The bright-yellow signage in the distance belonged to Mason's chemist's (now Waterstone's bookshop). The red car is a Swedish Saab and following behind is a Ford 105E Anglia.

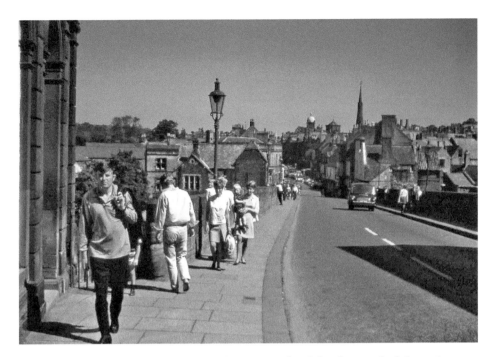

Looking over Elvet Bridge towards Old Elvet, 1968. Behind the chap on the left are the steps leading down towards Brown's Boathouse and the old House of Correction prison. In the distance, on the skyline, are the domed tower of Shire Hall, St Cuthbert's church tower and the spire of Elvet Methodist church. The vehicle is a Bedford CA van. (JS)

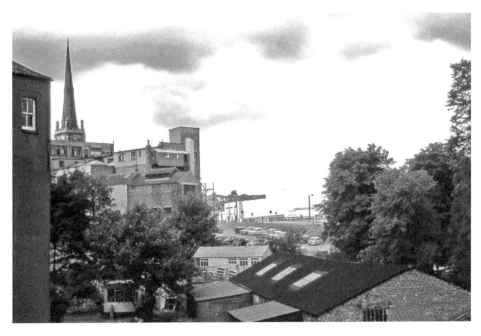

A view from Elvet Bridge, showing part of the area where Paradise Lane once crossed from Claypath to the riverside, 1968. The site was later partly occupied by the multi-storey car park. This, in turn, was demolished for the present Prince Bishops Shopping Centre. (JS)

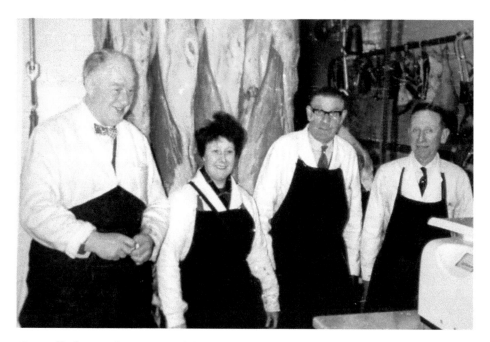

The staff of T. Heslop & Co. Ltd, butchers, 85 New Elvet, 1960s. Left to right: Norman Williamson, Elsie (?) (née Williamson), Norman Palmer and Syril Bell. The premises were large, stretching back to the riverside, complete with their own slaughter house. The shop is now occupied by a printing business.

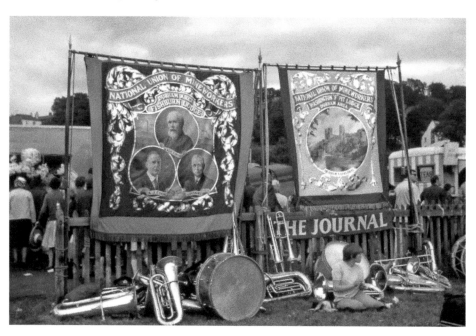

Durham Miners' Gala, 16 July 1966, showing two colourful banners: Fishburn Lodge (showing portraits of J. K. Hardie, A. J. Cook and G. Lansbury) and Washington 'F' pit. A young girl sits guard over the instruments, while the bandsmen probably have a drink or two in the nearby beer tent.

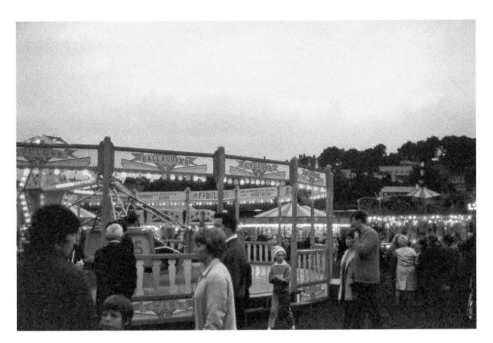

An early evening view of the fairground attractions on The Racecourse, at Durham Miners' Gala, *c.* 1960, taken by Janet Thackray. The ride in the foreground was called 'Gallagher's Cyclone'. It was around this time that hot doughnuts and the infamous hotdogs were introduced to the fairground as fast food.

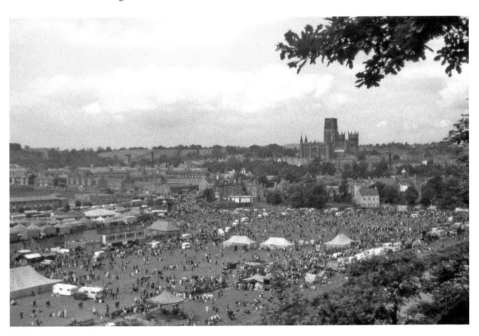

The Racecourse, from Pelaw Wood, Miners' Gala Day, 16 July 1966. On the bottom left is the old bandstand (*see p. 45*). To the left of the central area are the two terraced rows of Whinney Terrace, now the site of the new Durham Prison Gatehouse. The large white painted building on the right was the old St Cuthbert's R. C. School.

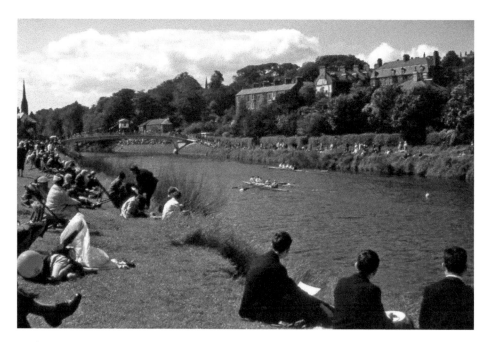

Durham Regatta, c. 1964. The first official regatta was held in 1834 and rowed upstream from Prebends Bridge. In 1851, the suggestion of rowing downstream was adopted for all races. On the opposite side of the river are the properties that were demolished to make way for the new Leazes Road. Immediately behind the bridge is Woodbine Cottage. To the right of that is Pelaw Leazes, then the gable end of Ravensworth Terrace and Pelaw Terrace. (JS)

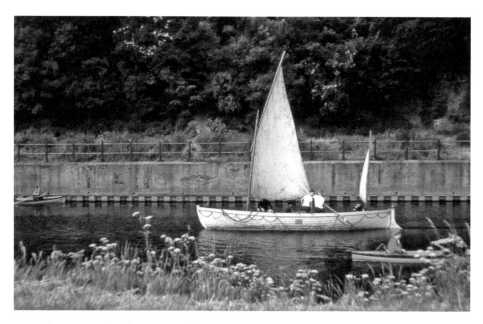

A small, private sailing boat – possibly sea scouts or cadets – on the river below Pelaw Wood, early 1960s, taken by Billy Longstaff. The others are on hire from Brown's Boathouse, situated near Elvet Bridge. The retaining wall supporting the footpath was constructed in the 1930s.

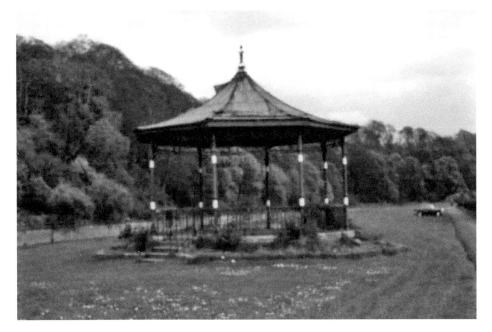

The bandstand on The Racecourse, 1968. Although the image is slightly out of focus, it is the only complete photograph the author has seen of the former structure. In the background is Pelaw Wood, given to the people of Durham by Lord Londonderry, as a memorial to those citizens who had paid the ultimate sacrifice during the First World War. (JS)

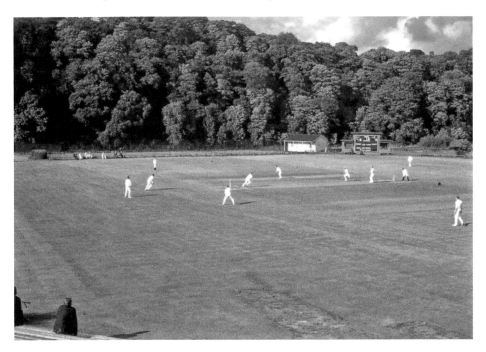

A fine view of Durham City cricket ground from the club house, The Racecourse, 1968. The club had just recently improved their old pavilion, which had originally been opened 2 May 1929 (replacing an earlier one). In the distance are the city tennis courts (*see p. 46*). (JS)

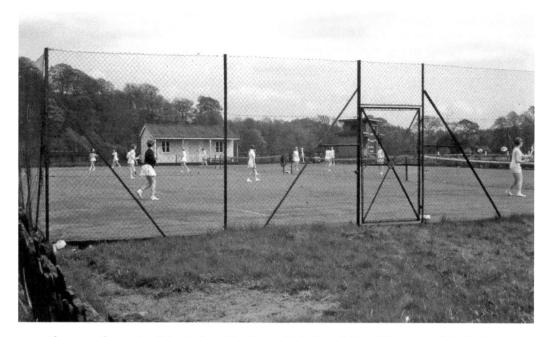

Players on the courts of the Durham City Tennis Club (founded in 1888 as part of the Durham City Cricket Club), The Racecourse, 1968. The pavilion was opened 24 May 1905. Unfortunately, the courts no longer survive. The cricket ground was situated to the right. (JS)

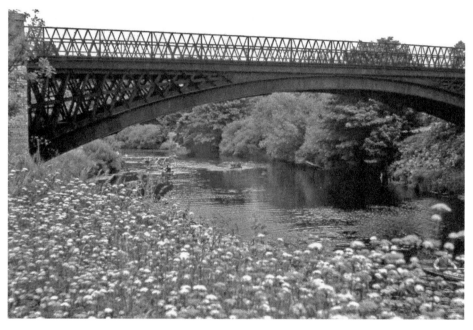

A fleet of hire boats from Brown's rowing upstream towards the iron railway bridge leading to Elvet Station, early 1960s, taken by Billy Longstaff. The bridge crossed the river at Old Durham Gardens and was erected in around 1892. The brick abutments still survive, along with a section of railway embankment.

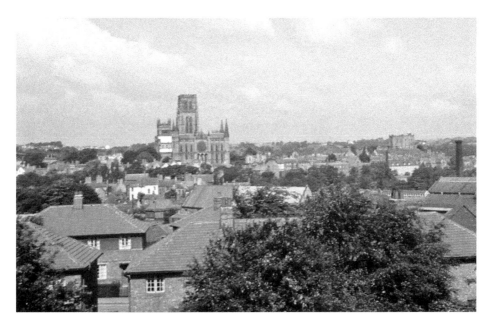

The cathedral and castle viewed from Whinney Hill School, *c.* 1960, taken by Janet Thackray. The red-roofed houses in the foreground are those of Whinney Hill, built in around 1926–28. On the extreme right, in front of the large chimney, are some of the rooftops belonging to Durham Prison. In the 1960s, some of the infamous 'train robbers' were housed here in the top-security 'E Wing'.

The cobbled lane of Elvet Waterside, 1969, taken by Hilary Webster. The site of the garage buildings in the distance is now occupied by riverside town houses, situated near the Baths Bridge. Also in the lane was Pattison's, the upholsterer's workshop, and Peele & McFarlane's veterinary business.

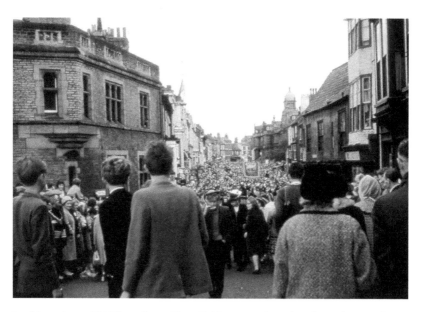

Looking along Old Elvet, from Elvet Bridge, *c.* 1960, taken by Hilary Webster. The occasion was the afternoon of the Durham Miners' Gala, when three chosen banners proceeded back to the city from The Racecourse to take part in a service at the cathedral. These large crowds were typical of the late 1950s and early 1960s. The stone building on the left was the County Court Offices (completed 1871). This and the building to its right (Waterloo Hotel) were demolished around 1971 for the access road leading to the New Elvet Bridge.

The Waterloo Hotel, Old Elvet, 1968, stood immediately to the left of the Royal County Hotel. To the left of the photograph is the entrance to the lane leading to Elvet Waterside (*see p. 47*). The building on the extreme left was then Durham Auto Electric Service Ltd, now the Swan & Three Cygnets public house. (JS)

Looking along Old Elvet, showing on the left the busy Elvet Bridge, 1968. The three vehicles outside the Royal County Hotel from the right are a 1965 Morris J4 GPO van, a Wolseley 16/60 saloon and an AEC Reliance tour coach from Nottingham, with Harrington Cavalier coachwork. (JS)

Looking along New Elvet from the junction at the end of Elvet Bridge, 1968. The ground floor of the large building on the left, 1 Old Elvet, was occupied by Greetings newsagent's. The two cars on the left side of the road are a Hillman Minx and a Morris 1000. Note on the right the Shell petrol sign belonging to J. McIntyre & Sons, garage and showrooms, 82–83 New Elvet, later occupied by Embleton's. (JS)

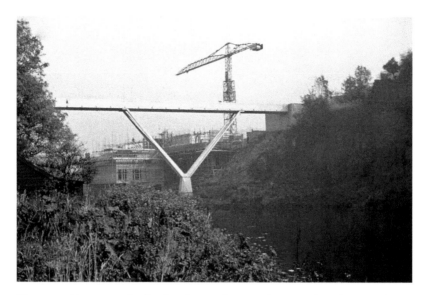

The new Kingsgate footbridge (opened December 1963) and, behind, the construction of Dunelm House (both designed by Sir Ove Arup & Partners), c. 1965, taken by Janet Thackray. During the late 1960s and the 1970s, it was a popular music venue, hosting bands including Pink Floyd and Procol Harum. According to their drummer, Simon Kirke, Free's most popular song, 'All Right Now', was written by bassist Andy Fraser and singer Paul Rodgers in their dressing room in Dunelm House, after a set of slower material had failed to excite the audience.

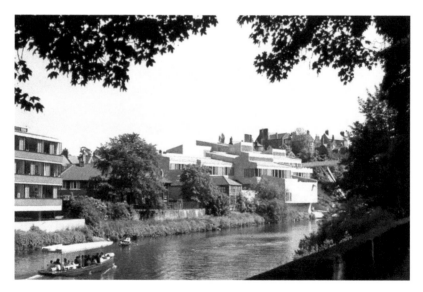

A view across the river from Fearon Walk, c. 1966, looking towards Dunelm House, which was started in the spring of 1964 and completed 1965 at an estimated cost of about £228,000. It was described by the noted architectural historian Sir Nikolaus Pevsner as 'brutal by tradition but not brutal to the landscape ...' On the river is the pleasure launch *Dunelm* piloted by Erik Whiteley. (JS)

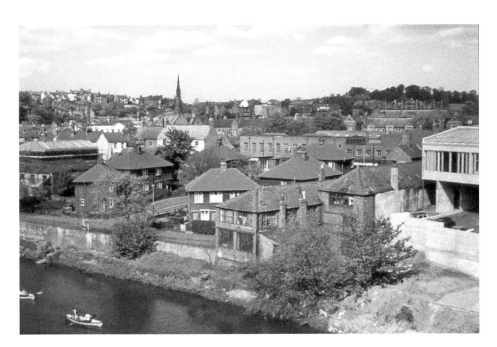

Looking towards Hatfield View from the newly constructed Kingsgate footbridge, *c.* 1966. These pre-war council houses were unfortunately later demolished. On the right is Dunelm House, the home of Durham Students' Union. The spire on the skyline belongs to Elvet Methodist church. (JS)

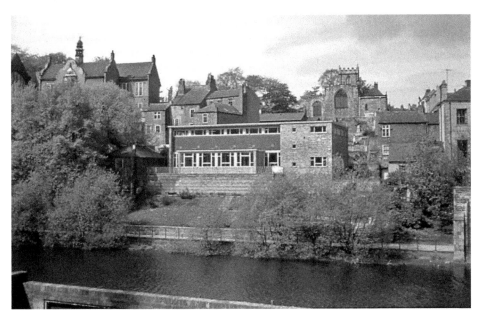

Looking across the river from below Silver Street, towards the newly constructed Durham City Library, early 1960s. The large building on the left was the old Johnston School in South Street. The church on the right is St Margaret's, in Crossgate, and on the extreme right is the former Criterion public house. The school and library sites are now occupied by modern town houses and apartments. (JS)

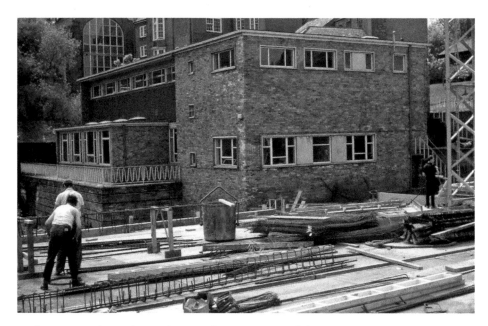

Durham City Library (opened November 1961) viewed from Framwellgate Bridge, 1968. The construction work in the foreground was part of the building of Bridge House and the Coach & Eight public house. This £200,000 development by Greensitt & Barratt Ltd of Newcastle was started in December 1967. It was constructed to the design of their architect, Mr N. D. Trafford. Immediately behind the library is the old Johnston School. (JS)

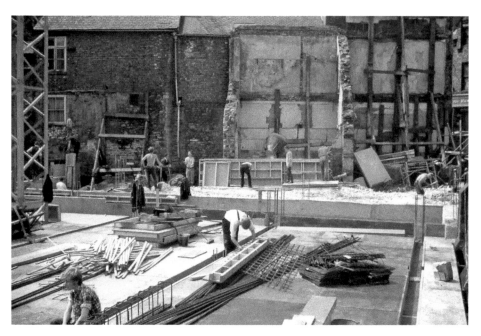

Construction workers busy building the Coach & Eight public house and Bridge House business premises on the North Road side of the Framwellgate Bridge, 1968. The buildings in the background were part of the Fighting Cocks public house. Note the lack of protective headgear; this was well before the days of Health and Safety regulations. (JS)

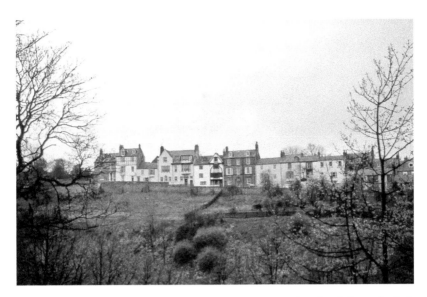

The top of South Street, as viewed from near the north side of the cathedral, looking over the wall behind the South African war memorial, 1969. The open area below the houses meant that the splendid view of the cathedral was not obscured. Unfortunately, this area, which had once been a market garden, has been left neglected resulting in numerous trees, which have self-seeded and grown to enormous heights, blocking the view from these properties. (JS)

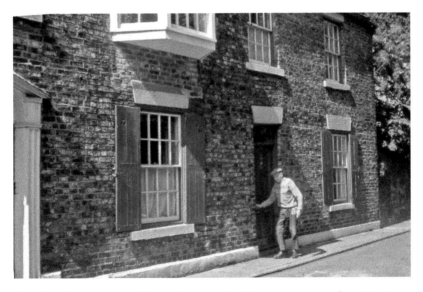

Number 36, at the top of South Street, 1969. The occupant was then Mrs Mary Seed. The old chap leaving the property was probably a neighbour. Note he is carrying a newspaper. Fortunately, the wooden shutters still survive on the ground-floor windows. The new brickwork above the window on the left suggests that the upper bay continued further down to the lintel of the window below. The doorway of 36 is now a window, and a small extension has been added to the right to form extra space on the first floor and a passageway leading to its new entrance. (JS)

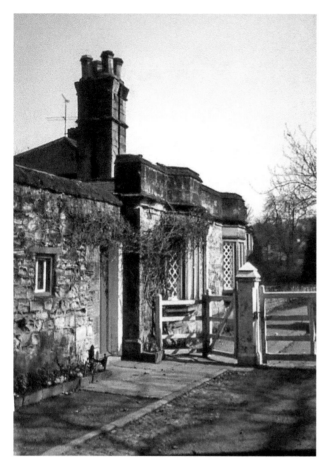

Left: Prebends Gate Cottage, belonging to The Dean and Chapter, next to the 'White Gates', Quarryheads Lane, 1969. Its large decorative chimney stack is now unfortunately decorated with an alarm box (fitted to the front), and wooden shutters have been fitted, distracting the eye from the decorative windows. (JS)

Below: The cathedral, from the front of Grape Lane council flats, Crossgate, August 1970, taken by Frank Wilson. The flats had been completed in 1967 and took four years to build after the first developer went bankrupt. They were finished by Messrs E. & A. Nelson Ltd, Langley Moor.

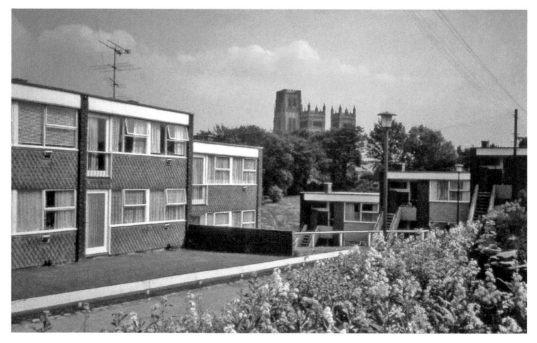

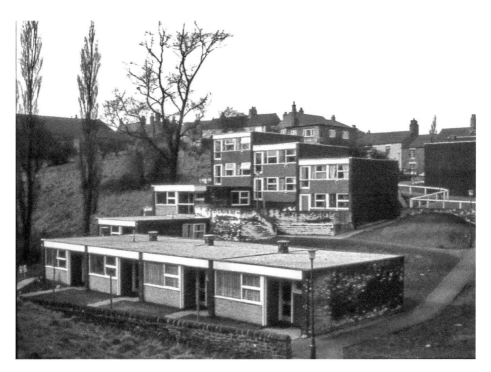

The Grape Lane flats, Crossgate, viewed from St Margaret's churchyard, 1967. These unsightly flat-roofed dwellings later had pitched roofs added. They were designed by Messrs Tarren & Caller, Newcastle. The white marks are salt escaping from the brickwork. (JS)

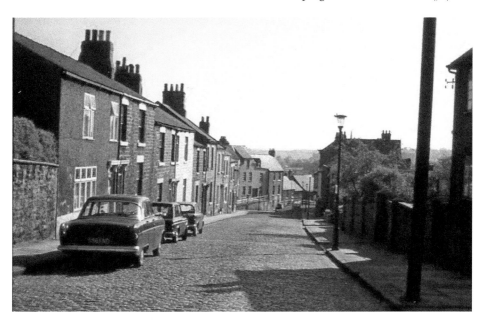

Looking down from the top of Crossgate, above the Grape Lane area, *c.* 1967. Note the cars facing downhill, showing that the street was then open for two-way traffic. The cars are a 1950s Ford Consul, an early 1960s Hillman Imp (built in Scotland), and a late 1950s/early 1960s Ford 105E Anglia. (JS)

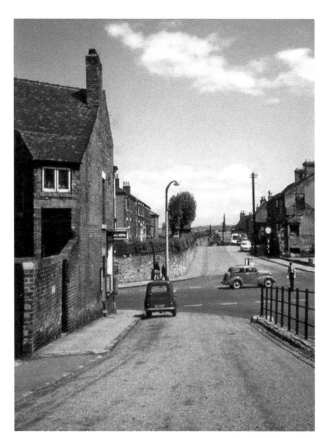

Left: The junction at the bottom of Crossgate Peth, 1965. On the extreme right, a policeman can be seen on 'point duty' (controlling the traffic at the crossroads). The van is an Austin A35 (popular at old car rallies now). The moving car is a 1950s Ford Popular. The shop on the left corner was then occupied by T. Robertson, general dealer, 1 Alexandria Crescent. (JS)

Below: Looking across to Margery Lane from the bottom of Crossgate Peth, *c.* 1963. The building on the right had previously been Williamson's butcher's shop. This and the buildings opposite were demolished in a clearance scheme in 1966. The car is a late 1940s Hillman Minx, Glasgow-registered with a learner behind the wheel. (JS)

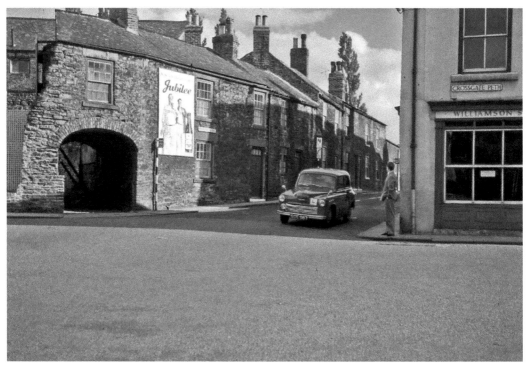

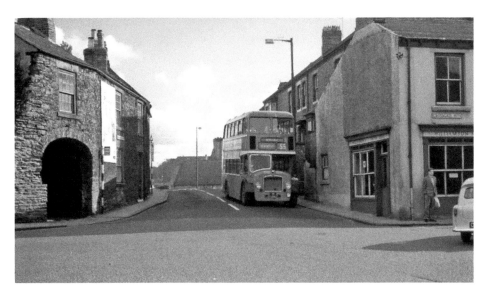

A Bristol Lodekka, of United Automobile Services, on the 55: Newcastle–Durham–Middlesbrough service (jointly worked with Northern), at the entrance of Margery Lane, c. 1963. Behind the bus on the right are the houses named Palatine View. To the left of the bus in the distance is the rooftop of St Margaret's School. The road on the right is Crossgate Peth. (JS)

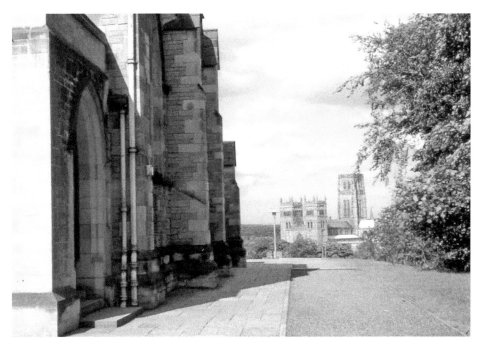

The Cathedral, viewed from the south face of Durham School Memorial Chapel (consecrated 30 September 1926), 1964. It commemorates ninety-eight former pupils, killed in the First World War; the seventy-nine names of those lost in the Second World War were also added to those on the stone pillars inside. The building, designed by W. H. Brierley, is accessible to the public on Heritage Open Days each September. (JS)

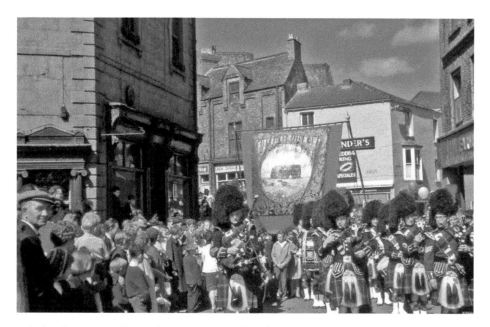

A lodge banner at the Durham Miners' Gala, photographed approaching Framwellgate Bridge, 20 July 1963. The banner from Marsden lodge shows Marsden Rock, and is being led in by a Scottish pipe band. The building on the left is the old Criterion public house, 1 & 2 South Street, and on the far right, the Farm Stores Ltd (*see p. 59*).

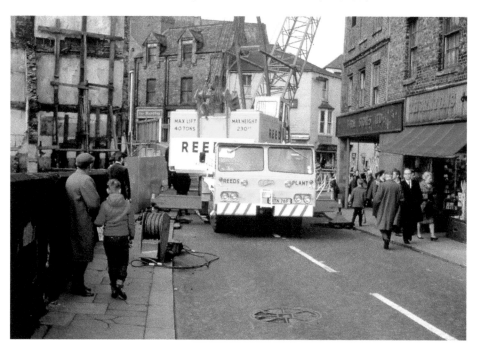

The same spot, five years later, when the Criterion has been demolished and a large crane is preparing to lift another crane on the construction site for Bridge House and the Coach & Eight public house, 1968. The crane is a Foden (lorry-derived) chassis registered at Newcastle in 1968. It belonged to Reed's Cranes of Newburn, Newcastle. (JS)

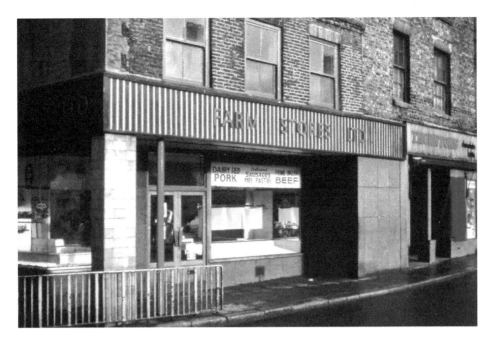

The Farm Stores Ltd, pork butcher's, Framwellgate Bridge, 1968. The shop to its right was Thornton's, the confectioner. They later relocated further to the right, and their old shop was opened up to become an entrance for the Millburngate Shopping Centre (since renamed 'The Gates'). (JS)

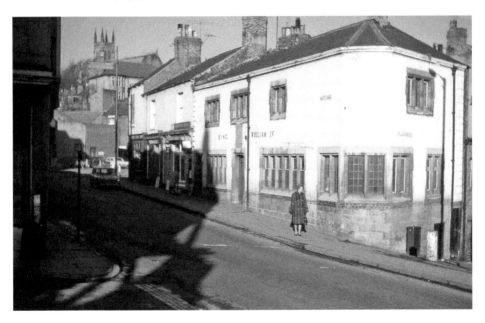

Looking across towards the King William IV public house, 89 North Road, from outside the Fighting Cocks, c. 1967. In the top left-hand corner, the tower of St Godric's church in Castle Chare. The sloping road on the extreme right led down to Millburngate. The site of the King William is now occupied by modern business premises attached to Millburngate Shopping Centre. The car looks like a Mini Traveller. (JS)

Stanton's fish and chip shop, 30 Neville Street, 1970. One of their previous shops had been in Millburngate (*see p. 87*). Although the business was sold many years ago and renamed, it has now reverted back to its original name, although not connected with the original owners. The car is a Vauxhall Viva, registered at Durham in 1968. (JS)

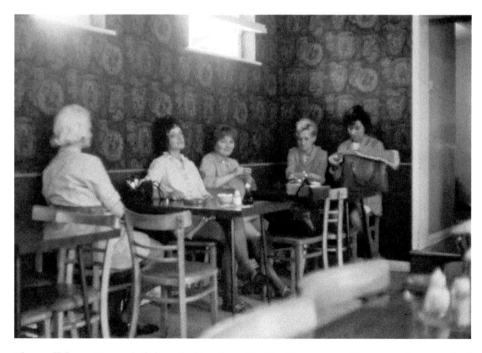

The staff from Stanton's fish and chip shop, Neville Street, 1970. They are photographed in the upstairs restaurant, having a ten-minute break prior to the start of their shift. A visit then was a welcome treat and you always received a first-class service. (JS)

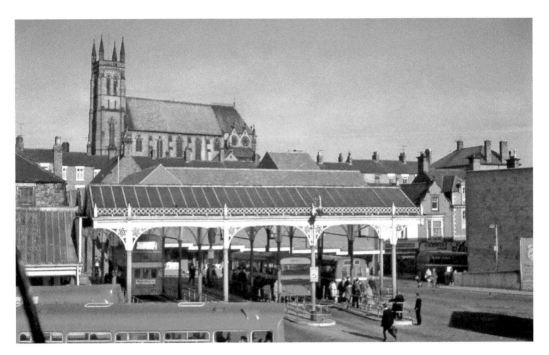

The 1920s cast-iron bus canopy, North Road, 1970. The skyline is dominated by St Godric's church in Castle Chare. The bus stand was taken down in the early 1970s, but a section of it survives in storage at Beamish Museum. Unfortunately, they arrived too late to save the rest from the scrap man. (JS)

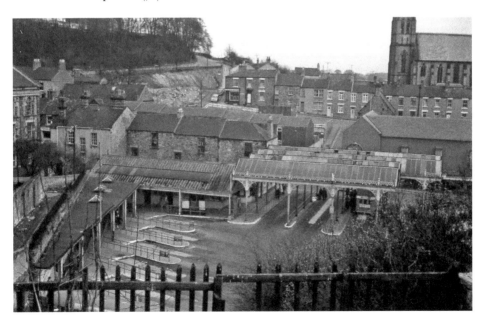

The bus station area viewed from a garden in Allergate, 1970. The stone building in the central part of the photograph belonged to Veitch, the printer. In the background is Tenter Terrace. The pile of rubble in the top central area of the photograph is near to where the Railway Hotel once stood (*see p. 78*). (JS)

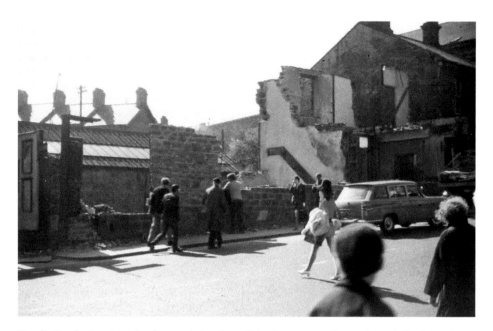

North Road, showing the front of the demolished property, formerly Veitch, the printer (*see p.61*), 1970. The area is now occupied by retail premises attached to the bus station. In the extreme top right-hand corner is the roof of the Bethel Chapel. The car is an Austin Cambridge Estate, and crossing the road behind it is a 'dolly bird' dressed in the height of fashion. The rooftops on the left belong to New Street. (JS)

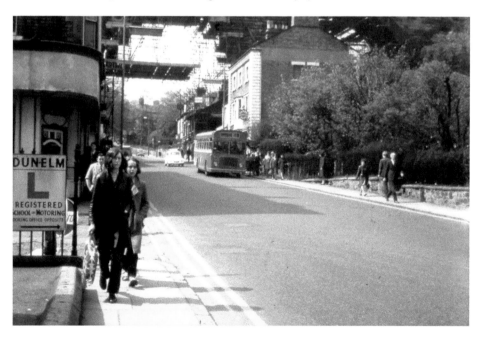

Looking up North Road towards the Station Hotel (behind the bus), June 1969. The open area on the right was then long front gardens belonging to town houses set back off the road (*see p. 67*). The scaffolding erected around the viaduct was for routine maintenance. The bus has the number 63 on the destination panel. (JS)

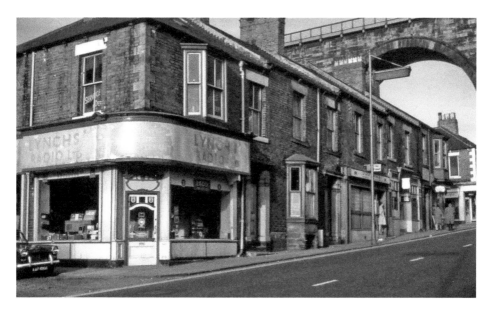

Properties at the top of North Road, 1969. The corner property, number 30, was Lynch's radio shop. A little further to its right was one of Durham's first Chinese restaurants, The Silver Palace. The building on the right with the green bay window belonged to Bramwell, bookseller and newsagent, and to the right of that was Durham Sewing Machines, which had previously been W. D. McCrae & Son, tailors. All of this area was in the way of the new road scheme, and was cleared in the late 1960s to make way for the North Road roundabout. The car parked on the left is a Triumph Herald. (JS)

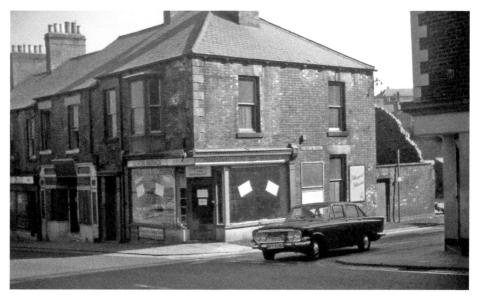

Looking across the road from outside the Station Hotel, towards Bramwell's newsagent's at the corner of North Road and Atherton Street, 1970. It was the oldest newsagent's in Durham, started by Mr A. Bramwell in 1906, at 6 Atherton Street, moving to this site in 1915. The business was purchased by the Young family (keeping the old name) in 1935, and it closed May 1970. The car leaving Atherton Street is a 1965 Ford Zodiac. (JS)

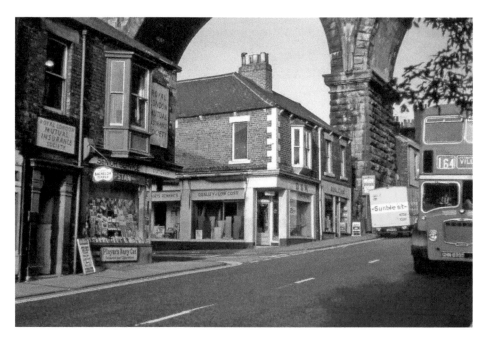

Top of North Road, showing the entrance to Atherton Street, 1969. Properties left to right, are the Royal London Mutual Insurance Society, Bramwell's newsagent, Durham Sewing Machines (DSM) and, next door at number 35, Ray Middleton's grocery shop. The double-decker bus on the right is the 164 to Sherburn Village. To the left of the Sunblest delivery van was the North Road public drinking fountain (*see p. 65*). (JS)

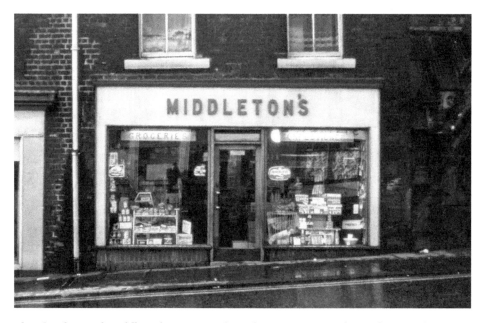

The shopfront of Middleton's grocer and confectioner, 35 North Road, December 1969. Immediately to its right was the public drinking fountain, now relocated nearby. After the shop was demolished in 1970, Ray Middleton later opened a smaller shop at 57 Claypath (*see p. 20*). (JS)

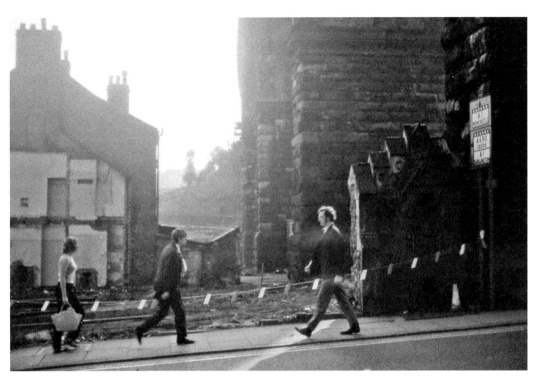

Above: The site of the former Middleton's shop after its demolition in 1970, overlooked by the massive piers of the viaduct. Note on the right the public drinking fountain. This had been erected by public subscription in 1863, and was fed by Flass Well (near the top of Mowbray Street). This area is now partly occupied by North Road roundabout. (JS)

Right: One of the many billboards which were situated around the top of North Road, 1970. This one was attached to one of the columns of the viaduct, to the right of Middleton's shop. To the right is the sign and doorway for C. W. Gibson, builder and contractor. Note the telephone number 107. Amongst the evocative set of posters is one for 'Harp, the cool blonde lager'. (JS)

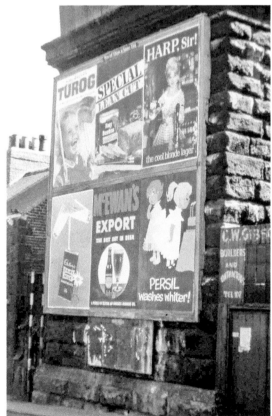

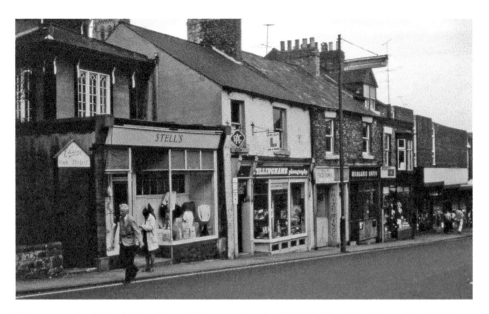

The top end of North Road, roughly opposite the Bethel Chapel, 1960s, taken by Janet Thackray. The business premises are, left to right, Elaine, hair stylist, Stell's, ladies clothing, the Dunelm Driving School, Fillingham's photography, Prize Bingo (the latter had previously been the Globe picture house), Midland Bank and John J. Gauden, gents' tailor and outfitter. All the properties apart from the last three were later demolished for the North Road roundabout area.

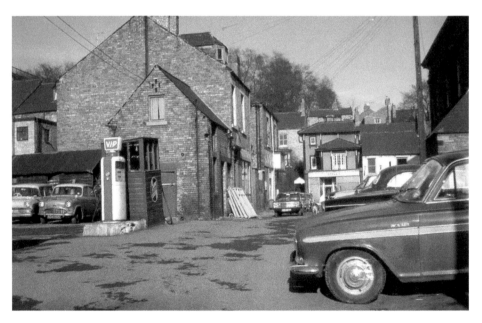

The North Road Garage, situated to the left of the Bethel Chapel, 1970. All the properties apart from the large building on the extreme right (the Bethel Chapel) were later demolished to make way for the new road. Two of the cars are an Austin Cambridge and Vauxhall Victor. Note the pump with its glass globe sign for 'VIP' (Vip-Petroleum). The railway viaduct is partly visible in the top left corner. (JS)

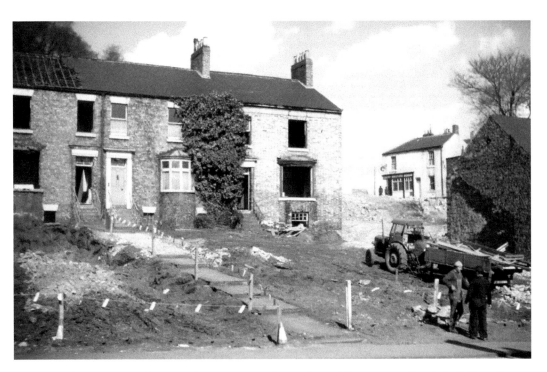

The demolition of the town houses in North Road roughly opposite the Bethel Chapel, 1970. As can be seen from the location, they had long front gardens. To the right of these houses, in the distance, can be seen the Royal Hotel in Castle Chare. (JS)

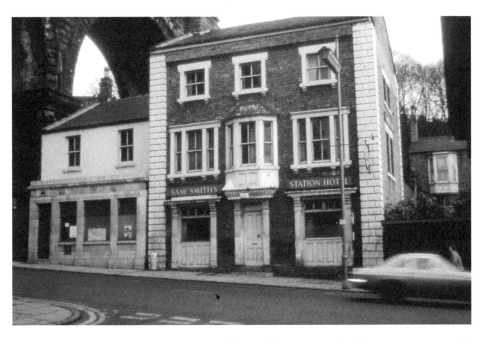

The Station Hotel, 45 North Road, viewed from the entrance of Atherton Street, c. 1968, taken by Janet Thackray. The premises on the left belonged to Searle, the dentist. On the far right was a bus stand, and behind it one of the smart town houses (*see p. 13*).

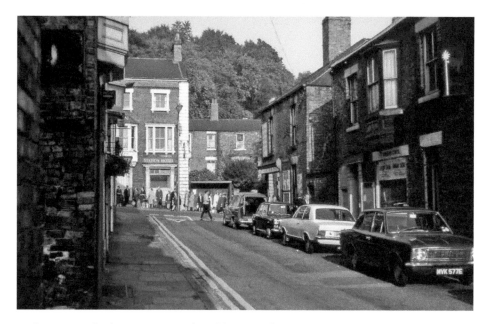

Looking towards the Station Hotel and bus stand in North Road, from Atherton Street, 1969. The car in the foreground is a 1967 Ford Cortina, behind a Vauxhall Viva and an Austin 1100. The shop on the extreme right has a vibrant coloured sign reading 'Bargain Centre', and was run by Tommy Metcalfe. (JS)

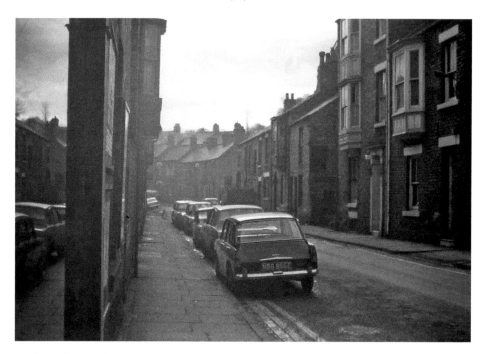

Looking along Atherton Street, in the direction of Hauxwell's iron foundry, 1970. All of this property was demolished for the new road system at the top of North Road. The car in the foreground is a 1967 Morris 1100. The three-storey property on the right was an eight-roomed guest house run by Margaret Hamilton. (JS)

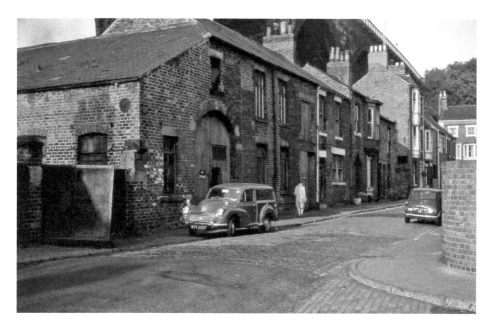

The frontage of Hauxwell's mechanical and heating engineers, welders and iron founders, 44 Atherton Street, 1969. It was founded nearby, in 1845, by George Hauxwell, later moving to this site in 1859. The business finally closed August 1969 after 124 years. The cars are a 1968 Morris 1000 Traveller, left, and a 1964 Mini, right. Note the viaduct in the top right of the picture and, on the extreme right, part of the frontage belonging to the Station Hotel. (JS)

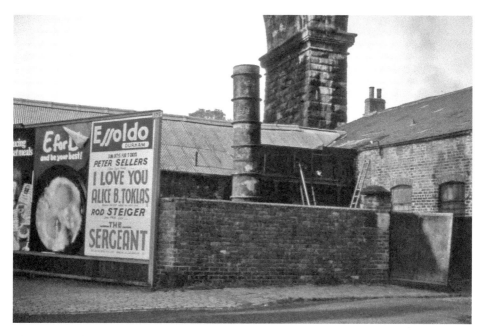

The yard and furnace chimney belonging to Hauxwell's iron foundry, Atherton Street, 1969. Many examples of their work can be seen around the city, in the form of drain covers and rain-water gullies. Note the billboard advertising the Essoldo Cinema, North Road, and one of the huge stone piers of the viaduct. (JS)

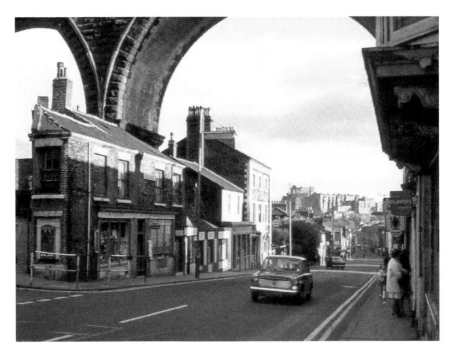

Looking down North Road from outside the Bridge Hotel, 1970. On the extreme left is the road leading up to the railway station. The car in the foreground is a Morris 1100. The corner shop on the left was Telfers, tobacconist and fishing tackle manufacturer, 43 North Road. The business was run by Norman and Jenny; they later moved to 45 Claypath and retired soon after to Carlisle, around 1973. Norman died in 1985. (JS)

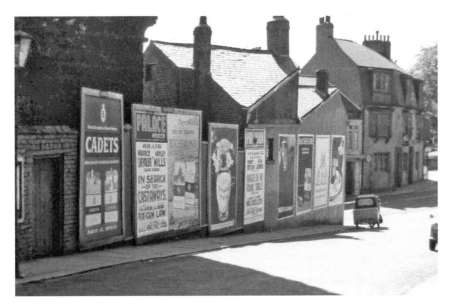

The billboards lining the walls at the lower part of Station Bank, just off North Road, 1970. On the extreme right is the Bridge Hotel. Note the vehicle on the right; this was an invalid carriage. Two of the posters advertise the Palace Cinema, Walkergate, and the Palladium Cinema, Claypath. (JS)

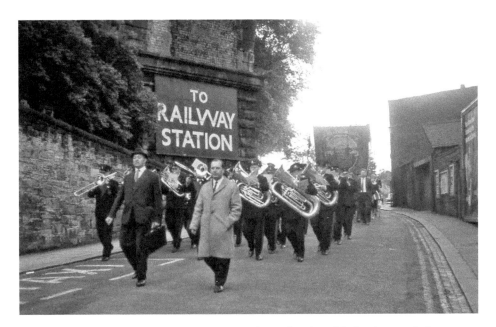

Looking up Station Bank, *c.* 1969, showing a brass band and lodge banner belonging to Harton & Westoe lodges. They are led by two officials, making their way down to North Road to take part in the Durham Miners' Gala. The banner shows a portrait of a family passing through the gate of a cornfield with the motto 'Security – Our Heritage'.

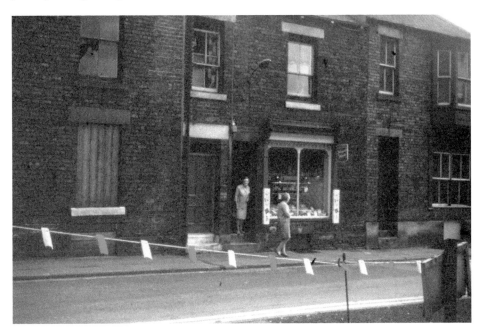

Mrs Phoebe Fox, at the door of her fruit and grocery shop, 5 Atherton Street, 1969. The property on the left is boarded up prior to demolition. As it was not in the way of the new through-road, the council did not want to buy it, so it remained for many years with its neighbour number 6. The site is now occupied by a modern building named Metcalfe and Hopper House. (JS)

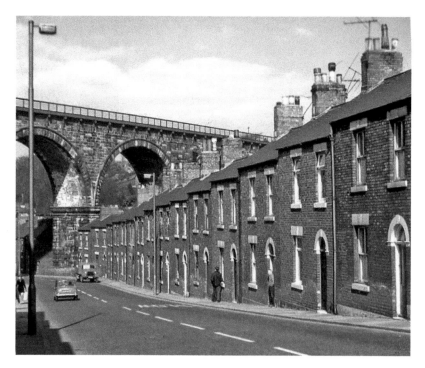

Looking down Sutton Street (built 1860), 1969. All of the lower section was taken down that year, for the construction of the new road linking up to North Road roundabout and Crossgate Peth. A Mini is seen travelling down on the left, and what looks like an ex-army wagon is parked at the bottom. (JS)

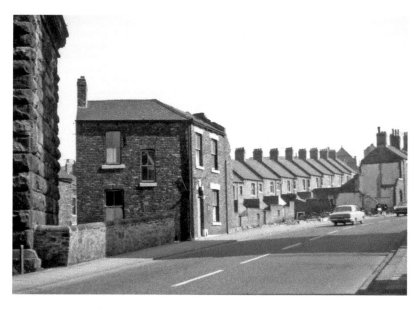

The upper part of Sutton Street being demolished, 1970. The terraced street in the background is the rear of Atherton Street, and at the end of that row on the skyline is part of St Margaret's Hospital, in Crossgate. The last car travelling up is a Ford Cortina MkII. (JS)

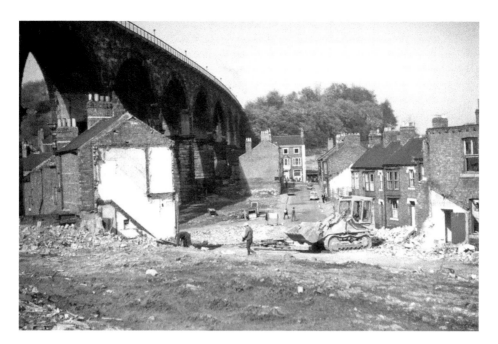

The Atherton Street area, looking more like a bomb site during demolition, April 1970. The central open area was where Hauxwell's iron foundry (*see p. 69*) once stood. The new road from Crossgate Peth crosses over this area today. (JS)

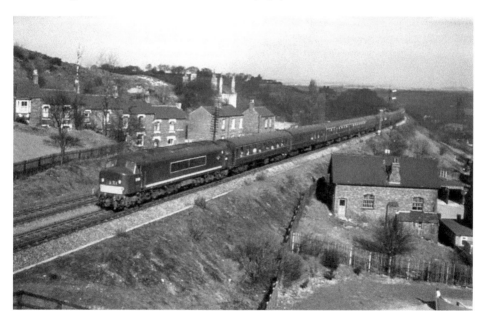

A Type 45 diesel locomotive on the main railway line heading south, *c.* 1968. The terraced properties on the left are in Redhills Lane. The small brick building on the right, situated at the top of Laburnum Avenue, was Durham's Jewish Synagogue (foundation stone laid 7 January 1910 and closed 1955); it was sold for £800. It is now a chapel belonging to Durham Presbyterian church. In the bottom right corner is a secluded public park, complete with the hull of a steel boat which still survives. (JS)

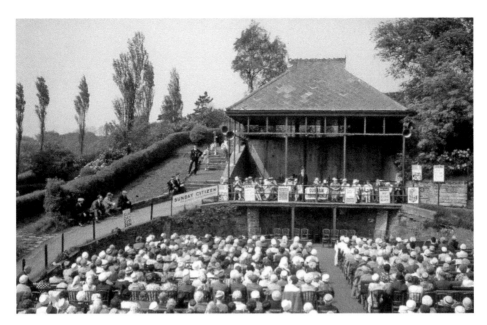

An annual gathering of women at the Durham Labour Women's Gala, held on the former roller-skating rink at Wharton Park, 8 June 1963. The seated guests are being addressed from the covered bandstand (one of the speakers was Mrs Bessie Braddock, MP). Unfortunately, its canopy no longer survives. Note that very few ladies are without a hat. (JS)

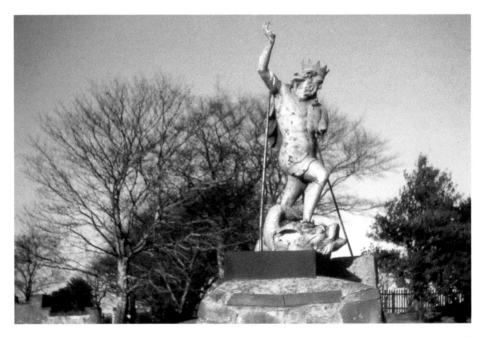

The lead statue of Neptune, on his stone plinth at Wharton Park, 1968. He was moved here in 1923 and remained until the early 1980s. The *Durham County Advertiser* reported, in 1965, that he had recently lost his left arm and trident to vandals (not by lightning as some suggest). After restoration, Neptune was returned to the Market Place, where he had originally stood. (JS)

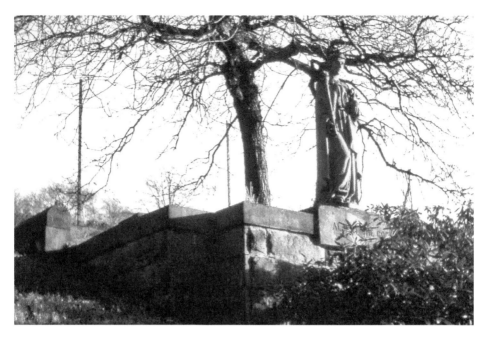

The stone statue of 'Albert the Good' (Queen Victoria's Prince Consort), situated on the North Road side of Wharton Park below the tennis courts, 1968. The head of Albert has been missing for many years. The remaining part of the statue is now in storage awaiting a new head. (JS)

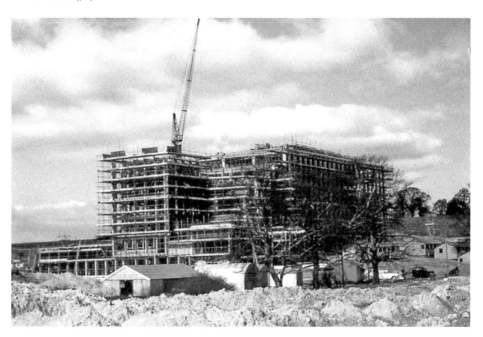

The building of Durham County Hall, c. 1962, taken by Stan Rand. Building work started in 1960, under the guidance of G. R. Clayton (County Architect), and was completed in 1963 by G. R. Gelson, his successor. It was officially opened by the Duke of Edinburgh, 14 October 1963.

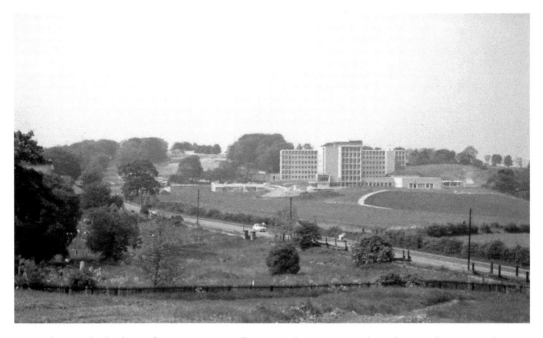

The newly built Durham County Hall, 1963. The view is taken from Wharton Park, overlooking St Cuthbert's churchyard. The old road is seen leading up from Framwellgate, prior to it becoming a northbound dual carriageway. The landscaping of the new building was designed by F. R. Atkinson, County Planning Officer. On the skyline to the left is Aykley Heads House. (JS)

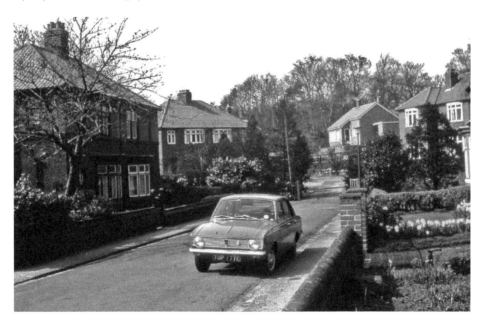

A springtime view of North Crescent, North End (the estate opposite Durham County Hall), c. 1967. The single car is a 1967 Hillman Hunter; not many cars parked in the street in those days. The trees beyond are in the grounds of North End House, at that time the Nurses' Home for Dryburn Hospital. (JS)

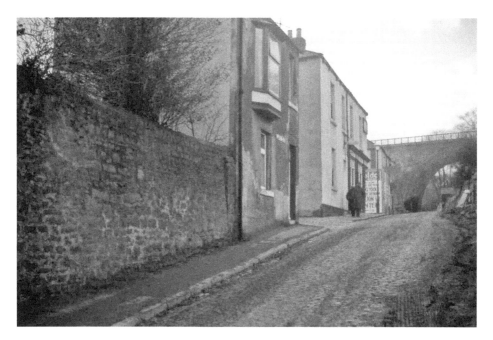

Looking up Castle Chare, 1970, towards the Royal Hotel. Beyond the billboards was the Railway Hotel. These properties were taken down when the new road was excavated from Millburngate to North Road. (JS)

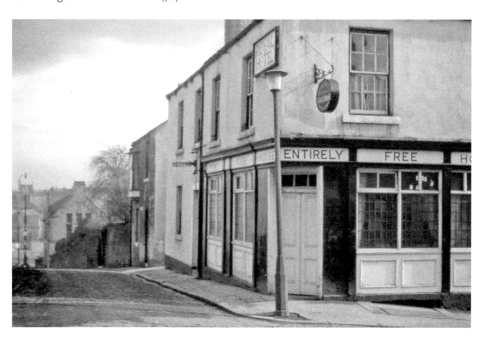

The frontage of the Royal Hotel, Castle Chare, 1970. In the distance, the red-brick building is the old St Godric's Roman Catholic School, Castle Chare, now converted into apartments. The illuminated sign above the hotel entrance was given some years ago to Durham Heritage Centre, where it is now on display. The road to the right led to Tenter Terrace (*see p. 80*). (JS)

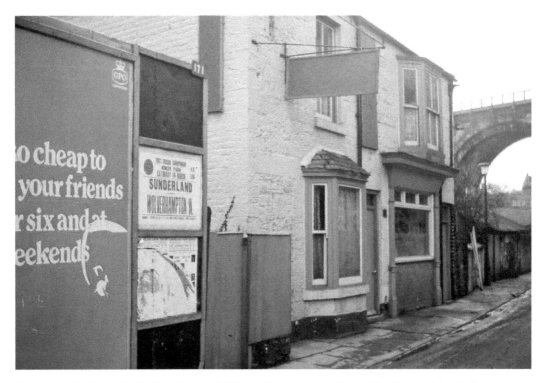

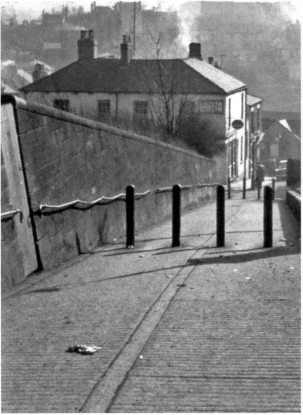

Above: The front of the Railway Hotel, Castle Chare, 1970, seen in its final days prior to being demolished. A poster on the billboard to the left is for a Sunderland football match against Wolverhampton, on the 14 March at Roker Park. On the right under the viaduct was the County Hospital. (JS)

Left: Looking down the footpath, leading from the railways station towards the Royal Hotel, Castle Chare,
c. 1960, taken by Janet Thackray. Beyond the hotel is the corner of Tenter Terrace. On the skyline are the rooftops of Crossgate. The hotel and the lane disappeared when the new road was being constructed, around 1970, linking Millburngate to North Road. Note how the metal hand-rail has sagged under the weight of generations of Dunelmians hauling themselves up the bank to the station.

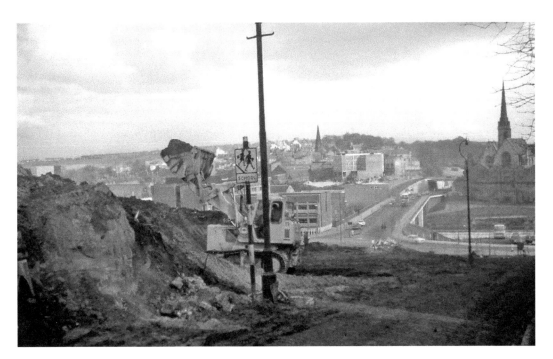

The new Millburngate Bridge, viewed from the top of Castle Chare, 1970. The bulldozer is seen clearing the site where the twelve houses of Co-operative Terrace once stood. Note the school patrol sign; this was alerting drivers to the nearby St Godric's R. C. School. (JS)

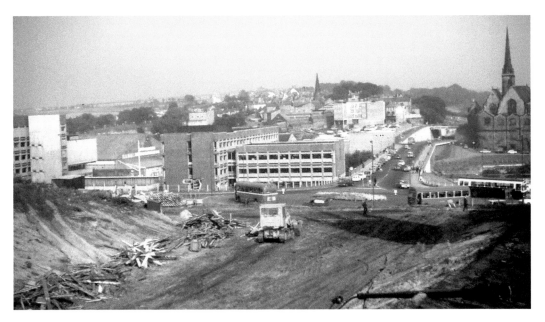

The construction of the new through-road, linking Millburngate roundabout to North Road, 1970. To the right of the photograph once stood Co-operative Terrace. Note the piles of scrap wood on the left of the picture; these were probably taken from the old houses. To the left of the roundabout is the recently completed Millburngate House, housing the Savings Certificate Office and Labour Exchange. (JS)

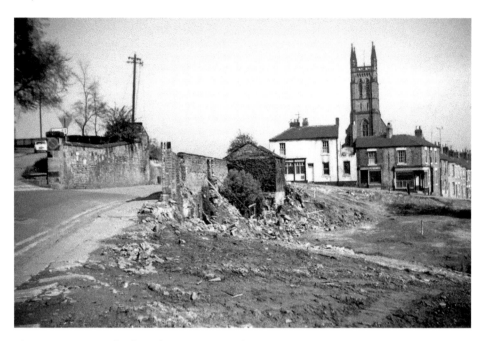

The entrance to Castle Chare from Station Bank, 1970. On the extreme left is the road leading to the railway station. To the left of St Godric's church is the Royal Hotel, and far right Tenter Terrace. Most of the area in the foreground was excavated for the new road. (JS)

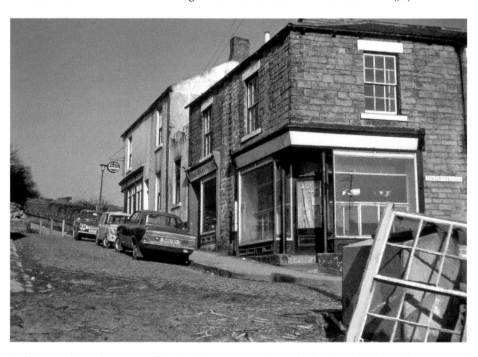

Looking up from the corner of Tenter Terrace, 1970, towards the Royal Hotel on the corner of Castle Chare. Beyond, on the far left is the footpath leading to the station (*see p. 78*). The two shops had previously been Durham Sewing Machines, left, and a grocer's, right. The gold-coloured car is a Vauxhall Viva, new in 1970. Behind it are a Mini Van and Ford Escort. (JS)

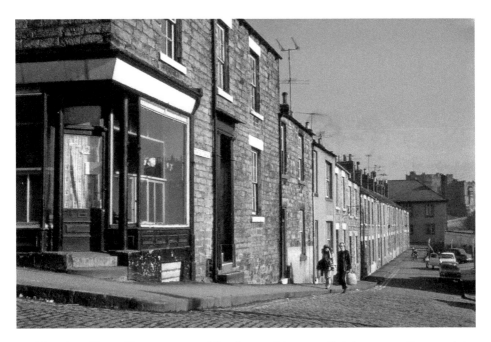

Looking along Tenter Terrace, *c.* 1970. The shop and the two adjoining properties were later demolished as part of the new road scheme. The large building at the end of the terrace in the distance belonged to St Godric's church, Castle Chare. (JS)

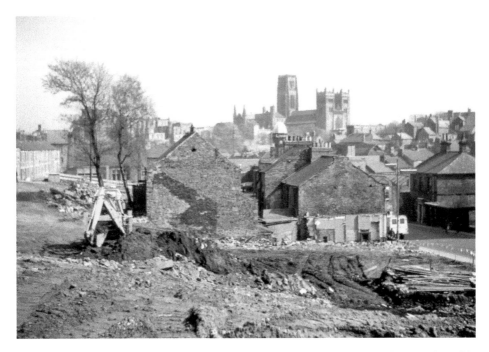

The desolate waste ground situated behind the Station Hotel, North Road, 1970. The gable end on the left, since altered, is now occupied by a restaurant, and on the right is the former Globe picture house, which later became a Prize Bingo hall (*see p. 66*). The left part of the photograph is where the present footbridge is situated. (JS)

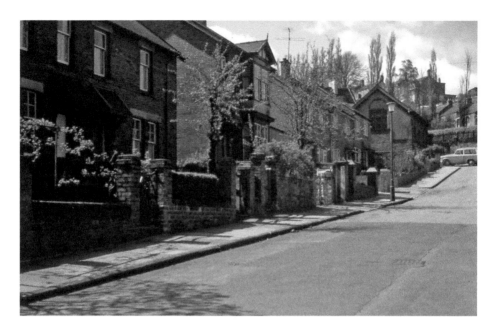

Looking along Laburnum Avenue towards the former Jewish Synagogue, seen at the end of the street, 1965. For many years, the building was used as a paint store, then offices, and has now reverted back to a religious meeting place (Durham Presbyterian church). The grassed embankment behind the fence, on the right, belongs to the main railway line, and beyond are the houses of Red Hills Terrace. The car at the top is a Hillman Husky (Minx 'Audax' based) three-door estate, produced between 1958 and 1965. (JS)

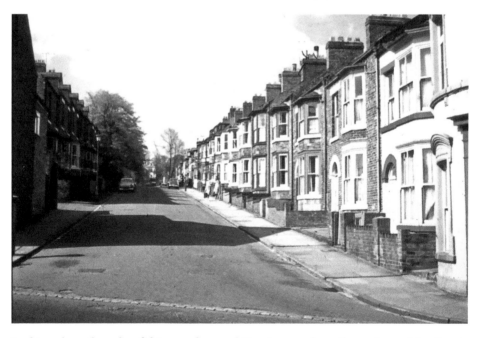

Looking along the colourful terraced row of The Avenue, from the main road leading to Crossgate Peth, c. 1965. Unfortunately, many of the properties are no longer family homes and are student-occupied. The building on the extreme right is now a music shop. (JS)

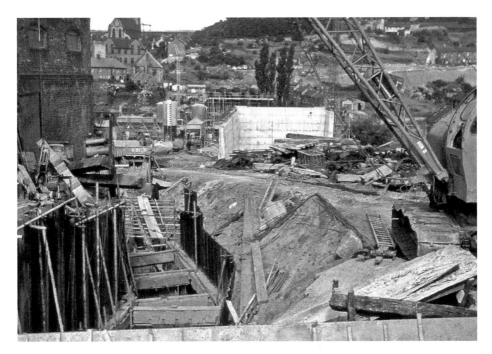

Looking towards the river from the bottom of Claypath, showing the construction of the underpass and Millburngate Bridge, *c.* 1965, taken by Janet Thackray. In the top right corner is the row of Gas Cottages in Framwellgate, and centre, under the crane jib, the roof tops of Fowlers Terrace.

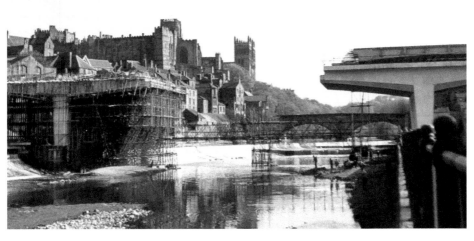

The building of the new Millburngate Bridge, April 1966. Note the large amount of scaffolding used to support the concrete sections. Work commenced in May 1964. The photograph was taken from the Millburngate side of the river. (JS)

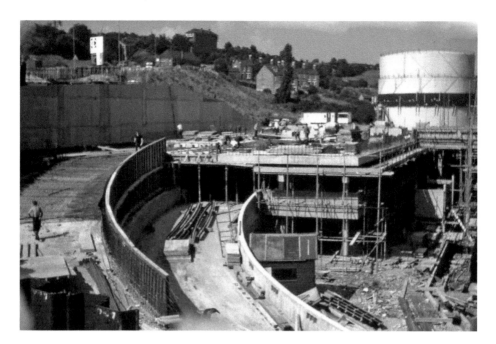

The construction of the first phase of Millburngate House, c. 1965. On the skyline is a signal cabin belonging to Durham Railway Station. The terraced houses situated in the distance are Diamond Terrace. Note the large gasometer on the right; this was one of two belonging to the City of Durham Gas Company situated in Sidegate. (JS)

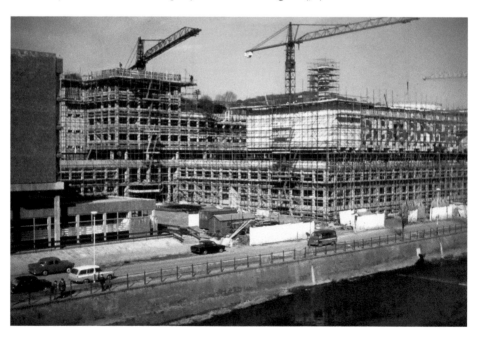

The second phase of the building of Millburngate House, c. 1968, taken by Janet Thackray. It was built in two phases between 1965 and 1969, and was officially opened by Princess Alexandra, 31 March 1970. The ground-floor section, on the left, was once the Labour Exchange, prior to its move to Hallgarth Street.

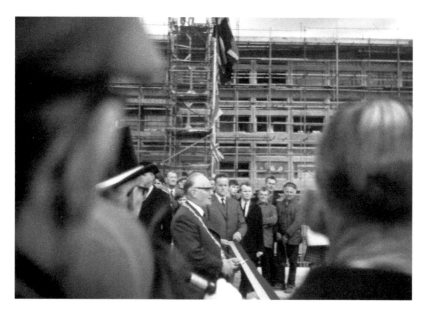

The official opening of Millburngate Bridge, 3 April 1967. The photograph captures the moment when the ribbon was cut by Councillor S. C. Docking, Chairman of Durham County Council. The bridge was designed by Mr W. H. Cotton, the County Surveyor and Mr G. W. Gelson, County Architect. The building work was carried out by Messrs Holst Ltd, Waddington Street. Millburngate House is seen in the background, still under construction. (JS)

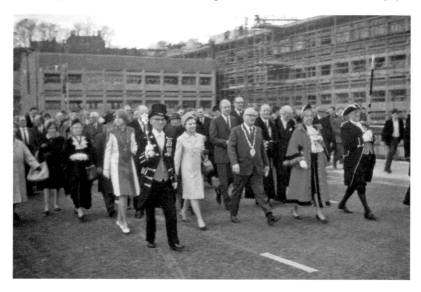

Councillor S. C. Docking, Chairman of Durham County Council, accompanies the Mayor of Durham, Cllr Mrs M. A. Thornhill and official dignitaries as they walk over the newly opened Millburngate Bridge, 3 April 1967. On the left is Cllr Mrs E. Blyth (with white gloves), and in the green striped dress, the Mayor's daughter Anne, who was Mayoress. The Sword Bearer on the right is Mr Herbert Ingram, from Gilesgate, and left the Sergeant at Mace, Mr J. T. Harrison. (JS)

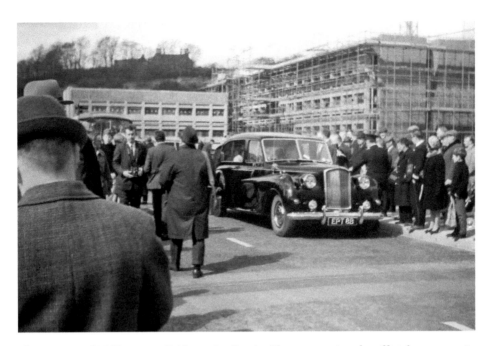

The opening of Millburngate Bridge, 3 April 1967. The car carrying the official party, a 1964 Austin Princess, was the first official vehicle to cross the new bridge. The bridge, 150 feet in length, was built at a cost of about £340,000. It was then forecast that 15,000 vehicles a day would cross the bridge. Today (2011) it is crossed by around 45,000. (JS)

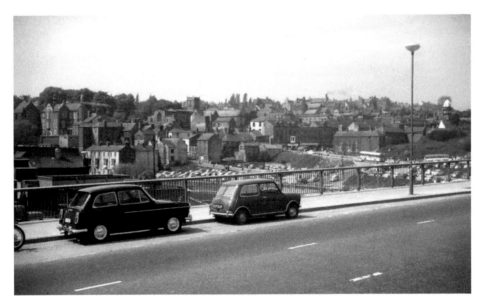

Looking towards Millburngate and the North Road area from the new Millburngate Bridge, 1968. On the extreme top left is the Johnston School in South Street. A little further to the right is St Margaret's church, Crossgate. Millburngate was then occupied by two large car parks, which are now the site of the shopping centre. The cars are, right, a Mini, F-reg (1968), and left, an Austin A40 Farina. This model has great historical interest, as it is the first 'hatchback' car, now almost universal in car design. (JS)

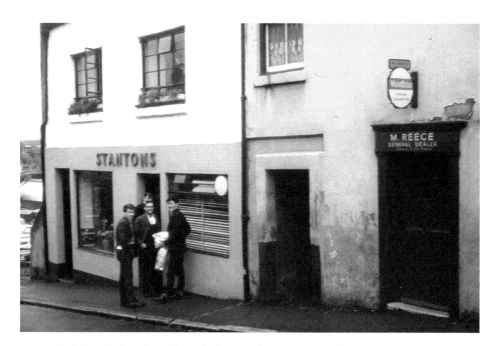

Stanton's fish and chip shop (then the best in the city), 128 Millburngate, *c.* 1966. The door on the right belonged to Maggie Reece's confectionery shop. When demolition began, this was found to be an ancient timber-framed building, and was incorporated into the design of the Framwellgate Bridge entrance to Millburngate Shopping Centre. (JS)

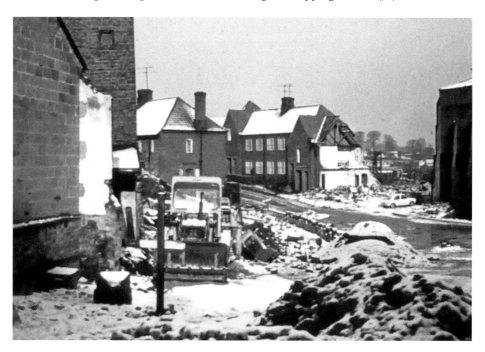

The demolition of the smart 1930s council houses in Millburngate, *c.* 1965. On the far right is part of Blagdon's leather works, which was demolished, March 1967. In the distance, on the right, is the medieval Crook Hall in Sidegate. (JS)

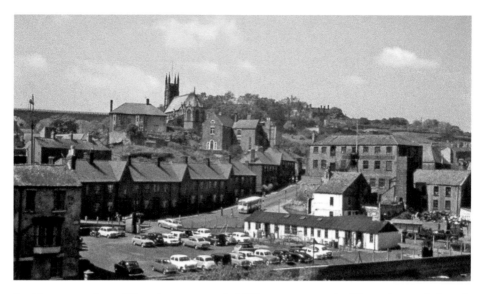

Looking across from Silver Street towards Millburngate, *c.* 1960. The red pan-tiled roofs belonged to the council houses, which were built *c.* 1935. The long, low building in the centre was Millburngate Nursery School. Behind that was Mary Lax's café and Luke Hanratty's scrapyard. The large brick building on the right belonged to Blagdon's leather works. The property in the central area of the photograph, to the right of the church, was part of St Godric's Catholic School. (JS)

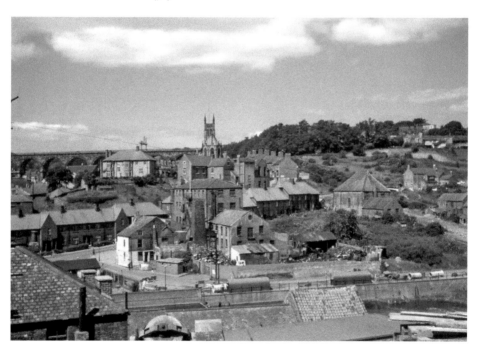

Looking towards Millburngate and the lower part of Framwellgate, 1963. The view is taken from Moatside Lane and shows some of the rooftops of Silver Street and, below, Fowler's Yard. On the extreme right of the photograph is the rear of The Bluebell Inn (*see p.89*); this was one of the last buildings to be left standing in Framwellgate.

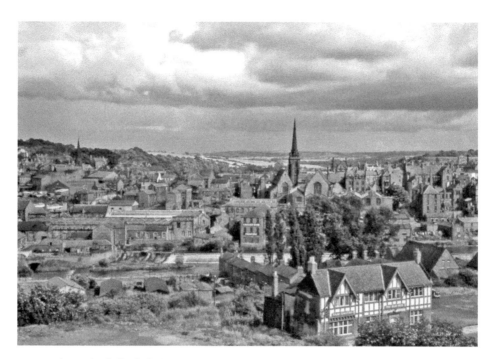

A view from the hillside below the railway station, in Framwellgate, looking towards the rear of Claypath and the Market Place, *c.* 1964. In the bottom right corner is the frontage of the Bluebell Inn, Framwellgate. The row of houses behind the pub were called Fowlers Terrace. (JS)

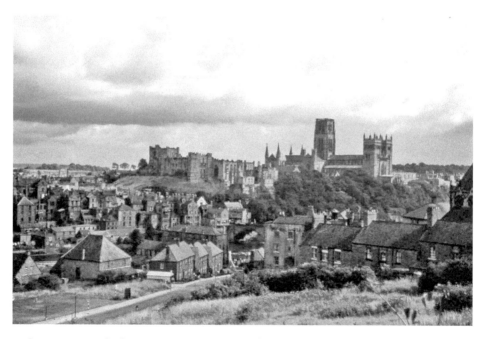

A fine view overlooking Framwellgate towards the castle and cathedral, *c.* 1965. The properties on the right were called Co-operative Terrace (built 1877); these were taken down to make way for the cutting from Millburngate/Framwellgate to North Road. (JS)

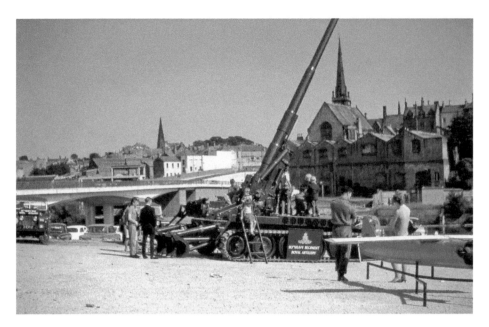

A recruitment display organised by the 20th Heavy Regiment of Royal Artillery, 1967, showing one of their large field guns being closely inspected by children at Millburngate open air car park. On the right is the latest remote-controlled aircraft, with a tiny 11½-foot wingspan, used for aerial reconnaissance. The spire on the left belonged to the Congregational church in Claypath, now redundant. (JS)

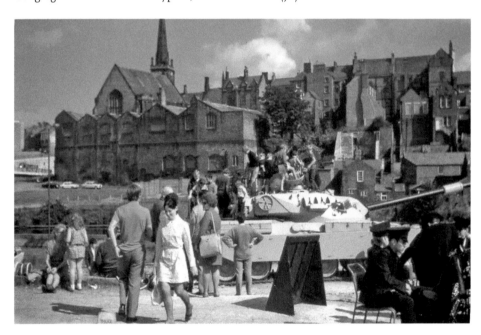

Millburngate open-air car park, 1970, then a popular venue for organised displays. The photograph shows a tank being looked over by local children. On the far right, a regimental band prepares to entertain. The large grey building on the opposite side of the river is the rear of the indoor market, and above it the town hall and spire of St Nicholas' church.

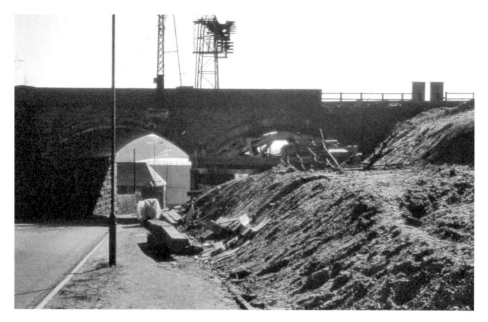

Looking towards the stone bridge belonging to the main railway line, at the top of Framwellgate, *c.* 1969. In those days, only one arch was open. The photograph shows preparations for the opening of the second arch and the widening of Framwellgate Peth into a northbound dual carriageway. Through the arch on the left is St Cuthbert's Mission Rooms, now offices. (JS)

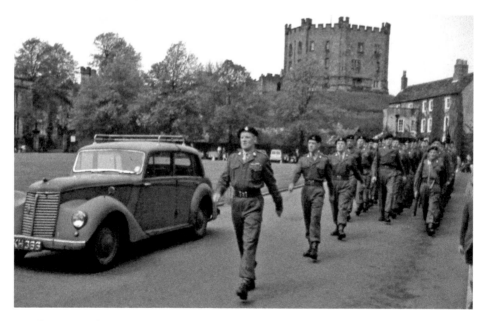

A military parade consisting of soldiers from the 8th Durham Light Infantry, 1960s. The soldiers are photographed marching on Palace Green, in the direction of the cathedral. They are led by Major J. Mulhall. The leading soldier on right is wearing an 'Inkerman' sash and chain bestowed on the D. L. I. after its performance at the battle, 5 November 1854. The car is a late 1940s Armstrong-Siddeley Whitley saloon, Hull-registered.

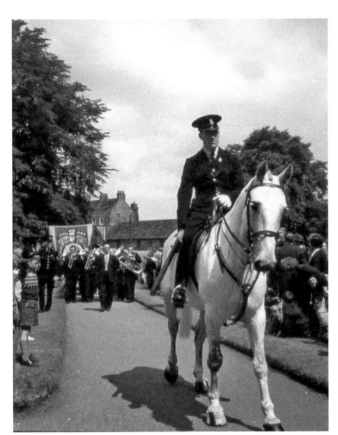

Left: A mounted policeman, PC Maurice Lowerson, leading one of the two colliery bands and banners, which were chosen that year to take part in the cathedral service for the Durham Miners' Gala, 20 July 1963. They were representing Washington 'F' and Brancepeth Collieries. A third lodge, Crook Hall, was chosen but did not attend. (JS)

Below: The Middridge Drift – located near Shildon – lodge banner (commissioned in 1957), showing a portrait of a pit pony, entering the north door of the cathedral for the special service of the Durham Miners' Gala, 21 July 1962. Note the banner is draped in black, signifying a death in the colliery since the last gala. The other two attending were from Harton Westoe and Dawdon Collieries.

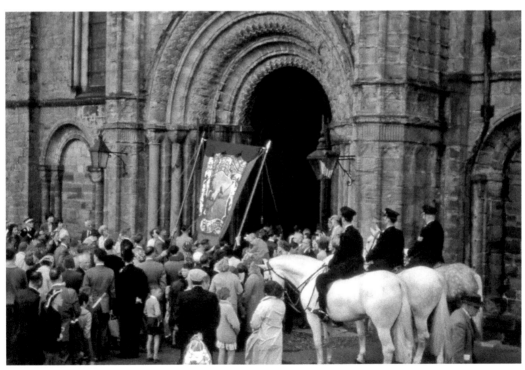

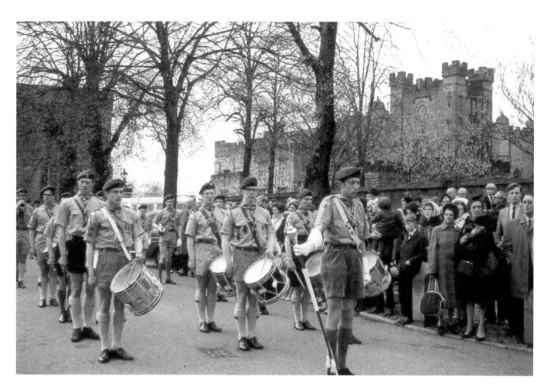

Above: A St George's Day parade, April *c.* 1963. A marching Scout band are pictured on Palace Green after a special service in Durham Cathedral. To the right of the photograph is the gatehouse belonging to the castle (University College). Note the spring blossom. (JS)

Right: Looking along Saddler Street in the direction of the Market Place, *c.* 1967. The public house on the left, number 59, was the Buffalo Head, now renamed La Tasca, and a little further down is the Shakespeare Tavern. On the extreme right is a small sign for T. Dewar, Craftsman Tailor. The two cars in the foreground are a Ford Corsair and, heading towards the Market Place, a Mini, behind which is the tall traffic sign at Magdalen Steps telling drivers to make a U-turn round the police box to reach Palace Green. (JS)

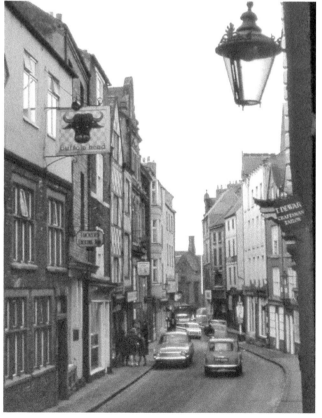

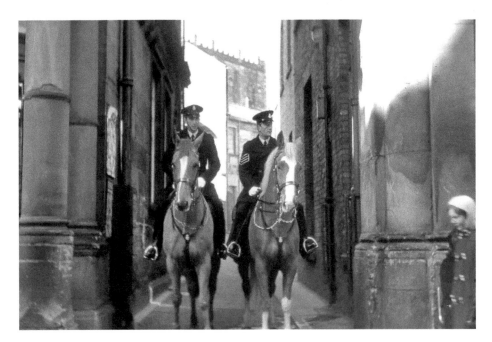

Two mounted police officers, PC Bill Pryce and Sgt Matt Hedley in the lane between the old *Durham County Advertiser* office and the employment office, Saddler Street, 1960s. The officers have top coats on, as does the young boy on the right, which suggests possible autumn or early spring. The mounted section were stationed at Harperley Hall.

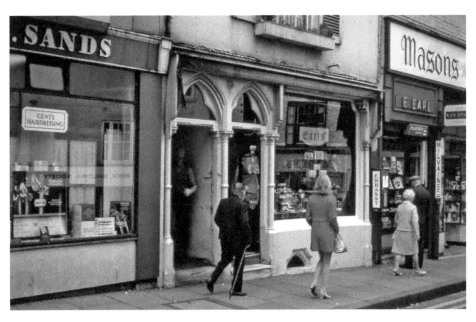

The ornate shopfront belonging to Earl Brothers' confectioner's, 68 Saddler Street, *c.* 1969. Earl's also ran the small tobacconist's at number 69, on the right, which consisted of a small area no bigger than a cupboard. On the left was R. C. Sands, hairdresser, and on the far right Mason & Co., chemist. Many people will remember having to queue at lunchtimes for Earl's famous meat pies. (JS)

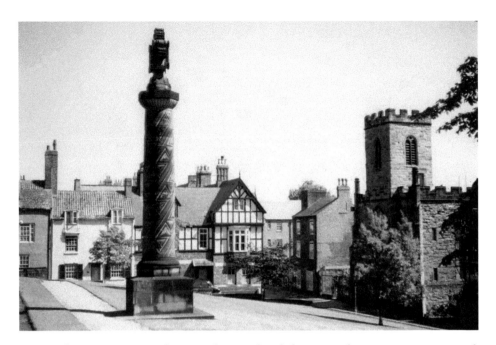

A view of Dun Cow Lane and St Mary le Bow church from near the County War Memorial, at the east end of Durham Cathedral, 1960s. Unfortunately, the memorial has been hidden from public view for many years, as a result of that area being used to store materials during restoration work on the cathedral. St Mary le Bow is now Durham Heritage Centre and Museum. (JS)

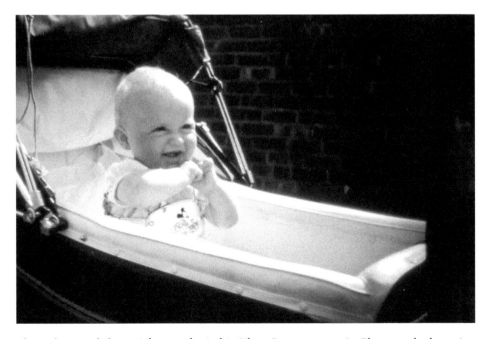

The author, aged about eight months, in his Silver Cross pram, 1963. Photographed wearing a 'Mickey Mouse' harness in his grandparents' yard at 27 Sherburn Road (near the 'road ends' Gilesgate).

Durham City Through Time
Michael Richardson

This fascinating selection of photographs traces some of the many ways in which Durham City has changed and developed over the last century.

978 184868 519 2
96 pages, full colour